"IT'S HARD,
BUT IT'S FAIR."

CLIFTON "POP" HERRING

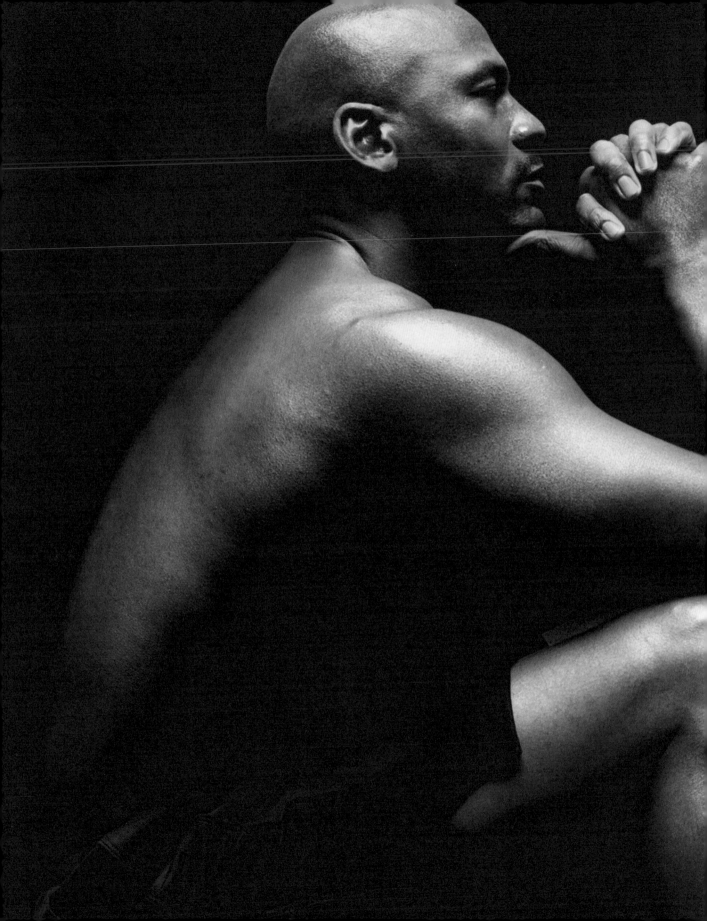

DRIVEN FROM WITHIN
MICHAEL JORDAN

Edited By

MARK VANCIL

ATRIA BOOKS

NEW YORK LONDON TORONTO SYDNEY

—

In August of 1984, at the insistence of my mother and father,
I boarded a plane to Portland, Oregon.

THAT DAY I MET PHIL KNIGHT FOR THE FIRST TIME.

Neither of us could imagine what the next 20 years together
would produce. Has it been a perfect partnership? No, but
nothing of value comes without hard work, particularly when the
objective is to create something no one could even envision.
Howard "H" White has said Nike was the perfect place for two
people as competitive as Phil and me because we could plug
into one another in an atmosphere that reflected our aspirations.
I think that's probably true. We might have come from
different places, but we have always shared a commitment to
creating products that reflect the same fundamental values.

BRAND JORDAN EXISTS BECAUSE OF WHAT PHIL KNIGHT CREATED BEFORE I EVER CAME ALONG.

—

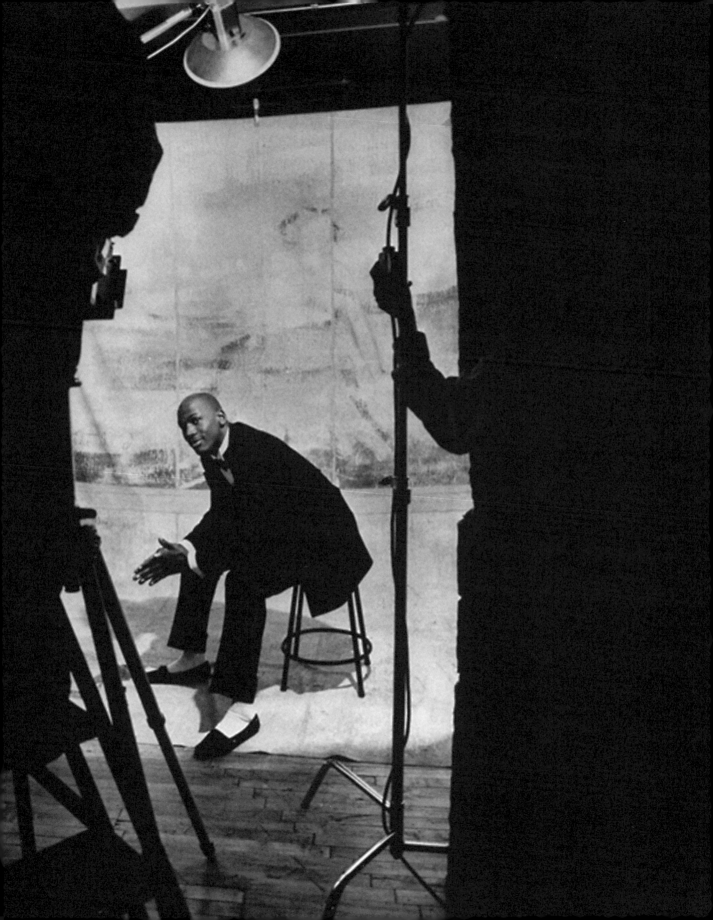

The call came from Tinker Hatfield, my friend and the design genius behind 14 of the 20 Air Jordan shoes. More than two years removed from the end of my playing career and 20 years into Brand Jordan, I was enjoying my life awayfrom the spotlight. I liked being behind the scenes and out of the public eye. In fact, I was doing just about anything to stay below the radar when Tinker called. He said it was time to look back, time to reflect on the arc of my life on and off the court. Tinker was coming back on board to create the Jordan XX, which would be designed on the idea of looking back over the last 20 years. It became an opportunity not only to reconnect with Tinker and revisit our creative process, but to talk about the basis for everything that had transpired. No one could have predicted the outcome because I was never following someone's lead or operating off an existing model. There were no models for what happened at Nike, and certainly nothing close to what we have created with Brand Jordan.

Everyone has theories, and it's easy to analyze events after the fact, but no one could have predicted everything would all turn out the way it has.

BUT LOOKING BACK WASN'T ABOUT CELEBRATING THE RESULTS AS MUCH AS IT WAS ABOUT UNDERSTANDING THE PROCESS THAT PRODUCED THOSE RESULTS.

And the process for me has always been pure. It's been about leading and staying true—authentic—to those fundamental values that flowed downstream from my parents and later Coach (Dean) Smith. Moving through the business world full time, I recognize that the structure of success is no different there than it was on the basketball court. Great companies have a lot in common with great teams. Players who practice hard when no one is paying attention generally play well when everyone is watching. Success at any level can be reverse engineered to reveal the same architecture.

THERE ARE NO SHORTCUTS. I HAVE ALWAYS BELIEVED IN LEADING WITH ACTION, NOT WORDS.

And I learned very early to follow my instincts. My standards have always been mine alone. I have never tried to be like somebody else, or live up to the expectations of others. I don't believe in following.

I believe in leading. That is the essence of Brand Jordan. There was never anything contrived about the way I played the game, and there is nothing contrived about what we have created at Brand Jordan.

This book provides snapshots, vignettes and stories about my life, virtually all of which can be seen in my shoes.

WE ALL KNOW OUR STORY FROM OUR PERSPECTIVE.
I WANTED TO KNOW WHAT IT LOOKED LIKE TO THOSE CLOSEST TO ME, THE PEOPLE INSIDE MY CIRCLE.

Everyone sees things from a different angle, and the people in this book saw everything from the inside out. Only people who are very close to me—other than my wife, Juanita, and our children—are included in this book. In some cases, a story is related and I provide my view of that same event. In other cases, I talk about what happened, or how I approached a phase of my life, and they respond from their vantage. Everybody knows the results. This book is about the process. The values that formed the foundation of my playing career are the same values that define Brand Jordan. I truly believe those values never go out of style.

MOM (DELORES JORDAN) *Where it all started.*

GEORGE KOEHLER *He was the first person I saw when I walked off the plane on my first trip to Chicago. From that first day, I never felt lonely in Chicago, thanks to George. And that's still true today.*

DAVID FALK *He taught me the business.*

TINKER HATFIELD *When it comes to anything to do with the design and creation of product, Tinker is my right-hand man.*

CURTIS POLK *My left-hand man, the person who watches the business.*

ROD HIGGINS *The teammate who showed me Chicago, a friend of 21 years.*

DEAN SMITH *My second father.*

HOWARD "H" WHITE *My first friend at Nike.*

FRED WHITFIELD *My friend of nearly 25 years.*

EARNED

WILL THERE BE ANOTHER MICHAEL JORDAN? SURE.

There is no doubt a player will come along who will be able to build on what I have accomplished, just as I built on the example of great players before me. But it won't be as easy for the next Michael Jordan.

TODAY, PLAYERS RECEIVE THE REWARDS BEFORE THEY PROVE THEIR WORTH. IF YOU LOOK AROUND, YOU'LL SEE THAT IT HAPPENS IN A LOT OF PLACES, NOT JUST SPORTS.

The big NBA contract comes with the big shoe contract. With those contracts come national commercials. With that kind of notoriety comes expectations, some of which are bound to be out of proportion to the player's experience and ability.

There were no expectations for me. Sure, I was the third pick in the NBA draft, and I received a contract worth a lot of money at the time. But no one expected me to become the player I became. I came in under the radar to a certain degree. Larry Bird, Magic Johnson, Julius Erving were the clear stars in 1984. In those days, no rookie was expected to come into the league and challenge the status of veteran stars. So I didn't have to be concerned with looking over my shoulder, or trying to live up to the expectations created by a marketing campaign. No one created a persona that I had to live up to.

WHAT I DID ON THE FLOOR DROVE THE MARKETING, NOT THE OTHER WAY AROUND. THE JORDAN BRAND WAS DRIVEN BY WHAT I DID EVERY NIGHT PLAYING THE GAME.

We had to earn what came to us. I never knew any other way, so I never thought otherwise. There wasn't a line of corporations looking to invest in young NBA players in 1984. Those kinds of deals happened because of what we were doing on the floor. It's often the other way around today, which makes it a lot harder for young players to realize the depth of their potential. It's hard to spend all summer working on one aspect of your game when you have already received the payoff. I never had that problem.

When my play started providing me with rewards, then I wanted to prove I deserved them. I never felt the desire to rest on what I had accomplished. I never felt like I deserved to drive a Bentley when I got my first contract, or live in a mansion. Those things might be symbols of success to some people, but there are a lot of people who confuse symbols with actual success.

WHAT'S LEFT AFTER YOU GET ALL THE MONEY AND BUY THE BEST CAR? THERE'S NOWHERE TO GO FROM THERE.

When we won one championship, then I wanted to win two in a row. When we won two, then I wanted to win three in a row because Larry and Magic never won three straight.

NOTHING OF VALUE
COMES WITHOUT BEING EARNED.

That's why great leaders are those who lead by example first. You can't demand respect because of a title or a position and expect people to follow. That might work for a little while, but in the long run people respond to what they see. They might even listen, but they usually will act based on the actions of the person talking. If the CEO skips out early on Fridays, then he or she has sent a message that tells everyone else they can do the same. I practiced hard every day because I wanted every one of my teammates to know what I expected out of myself. If I took a day off, then I knew they would, too.

Just like my high school coach, Clifton "Pop" Herring, used to say: "It's hard, but it's fair."

I LIVE BY THOSE WORDS.

Luck has not

IT ALL STARTED WITH AN APPETITE TO PROVE.

Whether it was competing with my siblings or trying to get attention from my parents, I wanted to show what I could do, what I was capable of accomplishing. I wanted results, and I was driven to find out the best way to get them. Of all the kids in my family, I probably was considered the one least likely to succeed.

I HAD NO PASSION FOR GETTING OUT AND EARNING A LIVING. HAVING FUN?
NOW THAT WAS A DIFFERENT STORY.

I had a passion for getting out on the playground and being my own person. I wanted to be different, to stand out. Playing kickball and being the star because I was able to kick the ball on top of a building, hitting home runs, stealing bases, pitching, scoring 30 points, blocking a shot, dunking—all those things drove me.

HAVING MONEY TO
BUY A PAIR OF SHOES?
NEVER DROVE ME.

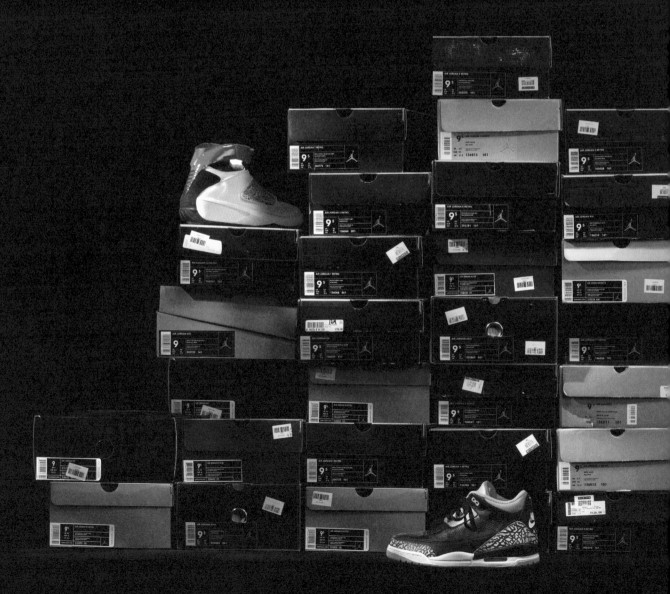

Working in the fields cropping tobacco, working at McDonald's, earning money so I could get a car and buy gas—none of that excited me. I figured if I was as good as I could be playing sports, eventually it would pay dividends. I didn't know how, but my focus was to be the best player in whatever sport I played. That was all I ever thought about.

—

MOM *More than anything, we tried to stress to Michael to enjoy what he was doing. Have a passion for what you are doing and work hard. If you don't enjoy what you are doing, then before long you are going to be tired and you won't find stability. If you have a passion, then you are going to be challenged every day to give your best.*

My mother was very sentimental and understanding of what I wanted to do. My parents wanted me to be equipped to go out in the world and earn a living. For my mother it was all about education. My father wanted me to be able to work with my hands, to be mechanical, able to work with tools. He thought that if you could work with your hands, then there would always be a job somewhere. I didn't have any passion for that kind of work. And that drove him nuts.

HE DIDN'T THINK I'D AMOUNT TO ANYTHING BECAUSE I HAD NO HAND SKILLS, NO MECHANICAL SKILLS.

The way my father looked at it, there was no guarantee I'd be able to make a living. But I never thought about that.

ALL MY ENERGY WAS FOCUSED ON GETTING WHERE I HAD TO GO.

My brothers could do anything. Larry could take a radio apart and put it back together. Ronnie was a business-oriented guy. He went out on his own at 18. He had jobs all through high school. He drove a school bus, and he always had a lot of responsibility. Larry drove a school bus, too. Me? I wanted no part of driving a bus. I didn't want to worry about kids yelling at me, or constantly have to pay attention to how fast I was going.

I WANTED THE FREEDOM TO DO WHAT I WANTED TO DO. AND I WANTED TO DO IT MY WAY.

Not blindly, but with my own twist. To this day, I don't enjoy working. I enjoy playing, and figuring out how to connect playing with business. To me, that's my niche. People talk about my work ethic as a player, but they don't understand. What appeared to be hard work to others was simply playing for me. We were playing a game. Why not play as hard as you can? There's no pressure in taking that approach. Play to win. Why else would you play?

I don't consider what I do at the Jordan brand working either, because I have a passion for the brand. I could sit around talking about shoe designs and fashion all day. You ask me to sit in an office and answer emails for eight hours—to me, that is work. When I got to the point of being able to apply my creativity to the game as a player, it expanded my understanding of who I was and what I wanted.

MOM *It could have gone either way with different parents who weren't there all the time. We were providing strong values to Michael. Would he fight with you? Yes. Even though sometimes he didn't understand what we were saying, we wanted him to know that what we were teaching him was designed to make him strong once he left our door. It was about making him have chores. Yes, you do have to cut the yard. You are going to learn how to make your own bed and hang your clothes up when you get home from school—this is your home. These are the things we taught our children. They had to have guidelines, and they had to be active in the home.*

But Michael wouldn't have done anything if we didn't remind him. He would have laid around and looked at the television all day.

We had one television in our home, and the only time they could look at television was Saturday morning. Other than that, it was studying. We knew where everybody was going. We knew who their friends were, and we knew their parents. We were involved in their lives.

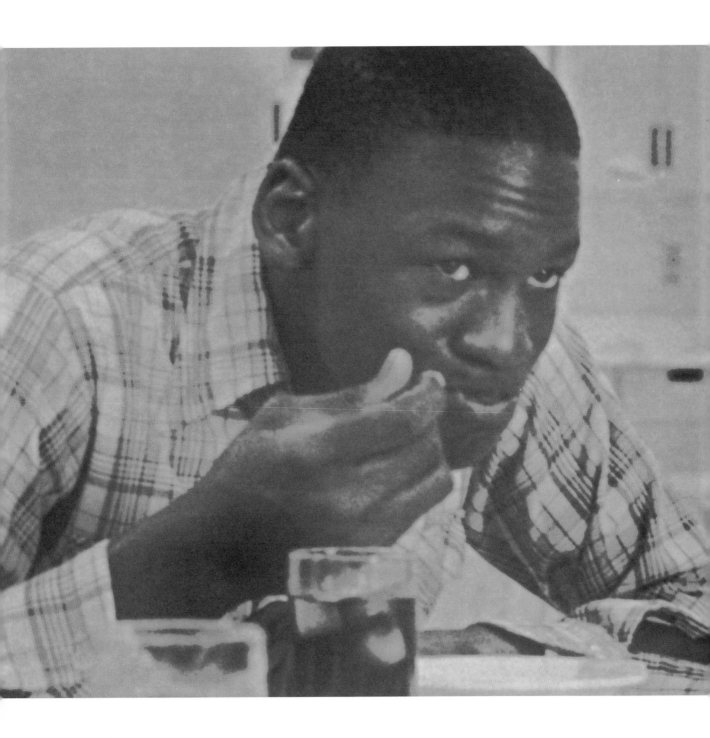

COACH HERRING WAS
THE FIRST ONE TO SEE IN ME
WHAT I SAW IN
MYSELF.

I relied on my high school coach, Clifton "Pop" Herring. He picked me up every morning my junior year, took me into the gym before school and worked me out. He was more or less my pusher. He was one of those coaches who just talked to you.

"YOU HAVE TO STAY FOCUSED, MJ."
"YOU CAN'T DO THIS, MJ."
"GRADES, MAN, GRADES."

Those where the things he would talk to me about every day.

I had tried out for Coach Herring's varsity team when I was in 10th grade. The team was stacked, but I felt like I was good enough to contribute. Coach Herring had another idea. I ended up playing junior varsity that whole season. When the JV season ended, players could be invited up to the varsity. But Coach Herring didn't move me up then either, even though I had averaged 26 or 27 points a game.

SO I ASKED TO BE STATISTICIAN. I WAS WILLING TO DO JUST ABOUT ANYTHING TO BE A PART OF THE VARSITY.

Coach Herring allowed me to go on trips, but the only way I could get into the visiting gym without buying a ticket was to carry somebody else's uniform so it looked like I was part of the team. When my parents heard I was going to the varsity game, they thought I had been pulled up. They got into their car, drove to the game. I never even got into uniform. I had so much confidence that I could help the team. I knew I could play.

Coach Herring could see that I had ability, but he also saw that I was a little slow in my development because I was growing. He knew I would make the varsity team that fall, but he wanted to start early. So he told me to stop playing football, which was fine with my parents. Then Coach Herring convinced them that picking me up every morning and working me out before school would be good for me. My parents agreed, but they had different motivations. They figured it would be a good way to make sure I got to school on time.

MOST DAYS I ENJOYED IT.
SOME DAYS I DIDN'T FEEL LIKE GOING.
BUT THOSE WERE THE DAYS COACH HERRING WOULD PUSH ME.

He'd pick me up at 6:30. We'd shoot jump shots, play one-on-one, and work on ball-handling drills because I couldn't handle the ball at all. We would work for an hour, then I'd shower and go to class. He made this big ol' poster with all the drills listed, and we went through them every single day. That's how it got started. Those mornings created a bond between us. He was a great guy, a YMCA kind of guy. He would counsel me on everything in life. He would give you the shirt right off his back and never ask for a thing in return. And he loved challenging me. He could shoot pretty well, so we'd play knockout, h-o-r-s-e, all those games. He'd stay out there as long as I would.

A lot of it was just high school. The way I looked at it, if you didn't have status in high school, then you really weren't anybody.

I DIDN'T HAVE STATUS. I DIDN'T HAVE ANY GIRLS.

I wasn't a great athlete at the time, though I wanted to be. Playing sports was my way of being able to move up the ladder. It wasn't just about fitting in—I wanted to *really* fit in. I wanted to be admired, respected. I wanted the girls to respect me, too. I didn't want to just carry their books. All of that drove me a lot more than most people think. I didn't want to be excluded from a grouping, or laughed at because I didn't have any status. If that's what you saw, I was going to prove you wrong. Just watch me—that was my mentality.

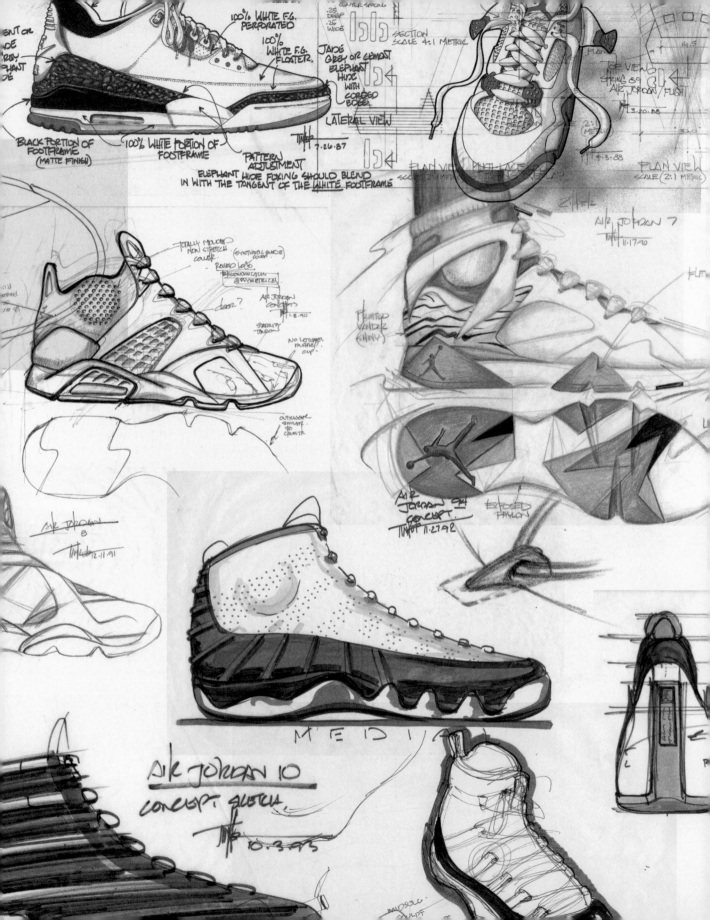

We have to adjust our expectations for players because times have changed. When I was growing up in Wilmington, North Carolina, we could only see two television stations, NBC and ABC. I never watched NBA basketball as a kid. I watched college games; we couldn't pick up an NBA game. Most of what I did growing up was born out of a desire to be the best player in Wilmington, or the best player in the park that day. I didn't have any sense of being the best player in the world, or playing in the NBA because I didn't have any idea what it took. I didn't even know what it looked like.

BUT I HAD NO DOUBTS OR FEARS BECAUSE I NEVER HAD EXPECTATIONS THAT WERE OUT OF CONTEXT WITH MY SKILL LEVEL.

My expectations were very low. I wanted to be the best player at the park in Wilmington. I wanted to be better than my brothers, or the other guys in the neighborhood. These were my expectations: make the varsity team, impress the coach, get a four-year scholarship to a major college.

WITH EACH PROGRESSION
I GAINED CONFIDENCE.

Even when I went to Chicago, no one knew my true ability because I had played within a system at North Carolina. Coach [Dean] Smith's system wasn't about excelling at one phase of the game. He was about excellence in every phase of the game: scoring, rebounding, passing, playing defense.

But in this era, the process is flipped.

NO ONE HAD TO MARKET MICHAEL JORDAN. I MARKETED MYSELF BY WHAT I DID ON THE COURT.

It's easy to see a guy averaging 30 points a game and then use him as a marketing tool for your product. It's a lot more difficult to take a guy you hope can play, market him as a 30-point scorer, and then find out he's not nearly the player your marketing platform promised. You can't fake out the consumer. Some of these kids today can never live up to the expectations created for them.

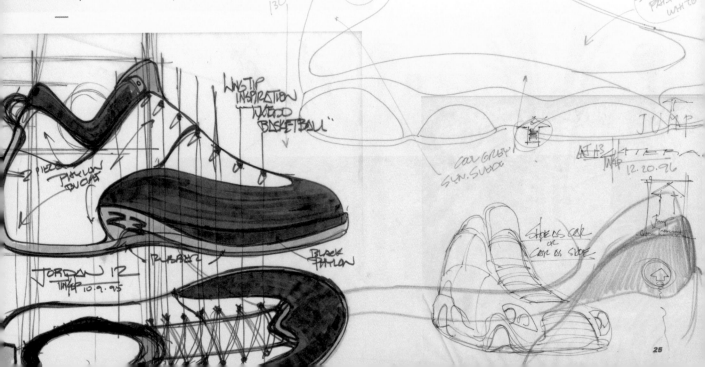

COACH HERRING LIED TO GET ME INTO THE 5-STAR BASKETBALL CAMP IN PHILADELPHIA BETWEEN MY JUNIOR AND SENIOR YEARS IN HIGH SCHOOL. I WASN'T ON ANYONE'S LIST. YOU COULDN'T FIND ME RANKED ANYWHERE BECAUSE NO ONE KNEW I EXISTED. I LITERALLY CAME OUT OF NOWHERE.

That's impossible today. There are scouting services evaluating 12-year-olds. Back then, no one was looking for basketball players in Wilmington, North Carolina. I grew almost four inches to 6-foot-3½ that summer. I was really kind of clumsy. But I had a great junior year, so Coach Herring decided he needed to get this kid some publicity. The only way you could get into the 5-Star camp was by being one of the best-ranked players in the country. I wasn't ranked anywhere by anybody.

COACH HERRING TOLD THEM I AVERAGED 35 POINTS, 20 REBOUNDS AND EIGHT ASSISTS, SOMETHING LIKE THAT. AND THAT'S HOW I GOT IN.

When my father drove me up to Philadelphia to drop me off, that was the first time I had ever been to a basketball camp. I won five trophies the first week. So before my father came back to get me, they asked him if I could stay another week. Howard Garfinkel, who ran the camp, told my father, "Mr. Jordan, if you let him stay, I guarantee you he will get a full four-year scholarship. He might even be a McDonald's All-American. It would be financially so much better for you to let him stay another week." That's the only way I stayed for that second week.

MOM *It was hard work and commitment between Mr. Jordan and me when Michael and his siblings were growing up. We really learned how to budget. We did it together. Each week we would sit down and figure out what bills we were going to pay. We had paid for one week of basketball camp, and when Mr. Garfinkel called, we told him we only had money in the budget for that one week. Mr. Garfinkel just let us have it. He told us we didn't know the skills of our son.*

I said, "Sir, that's OK. We paid for one week and we're coming to get him." He said, "I'll give him the money." We said, "We don't know you and we can't take your money." Then he said he would give Michael a job washing the dishes to pay for the second week. We had a budget, and we had to stick to it.

I was full of energy after that second week. I thought I must be doing something right. All I wanted to do was to improve, to keep getting better.

IT WAS LIKE THE BLOOD STARTED RUSHING.

I became a sponge. I got a glimpse of what success looked like. I saw where I fit with the best players in the country, and they were all there: Chris Mullin, Patrick Ewing.

That's when my parents started to believe that this kid could amount to something. They started supporting me and pushing me. My mother was very adamant about me making the grades.

If I didn't make the grades, then she wouldn't let me play basketball. My father just kept saying, "Keep playing, keep working." My mother never believed sports should be ahead of education—she still believes that today. My father was beginning to see the same things I was seeing.

HOWARD "H" WHITE *Michael Jordan is very, very astute and very intelligent. He had something that a lot of kids don't have: a mother and a father. So he came from a family, a family that had direction, discipline, the kind of foundation that can give people a chance in life.*

A lot of kids today need reinforcement. They need a pat on the back. Back in those days, if you didn't get the pat, you better pat yourself and keep moving. At least it was that way for me. And that knowledge helped me understand some things. I told myself that whatever I did in life was going to be done my way. I knew I had to abide by the basic rules—I knew right from wrong. I wanted to be different. When it came time for me to decide on colleges, I had all kinds of people telling me to go to the Air Force Academy, or to a smaller college where I would be assured of playing. I'm saying,

"I'VE GOT HIGHER DREAMS THAN THAT.

"I'm going to North Carolina. I'm going to a place no one else from my town has ever gone. You can say whatever you want, but I'm going. If I have to sit on the bench, at least I'm going to learn how to sit on the bench with the best." One teacher said, "You'll be back here in Wilmington pumping gas if you don't go to the Air Force Academy." Yeah? We'll see about that.

My parents just wanted me to get a scholarship so they didn't have to pay. My mother was going to make sure I had the right focus academically. My father more or less thought, "At least this guy isn't going to be home for the rest of his life. He may just get out and do something."

—

MOM *At the University of North Carolina, we had an opportunity to see Michael's skills and the passion he had playing. Prior to Chapel Hill, for us it was all about education. No matter how much money you make, education is something no one can take away from you. No doors can close in your face; you have all the tools. That was the number one priority for us when Michael went to North Carolina. Everything with basketball was gravy. I remember thinking, "You mean we aren't going to have to worry about tuition?"*

There were a lot of doubters when I was deciding on schools. But my father didn't waver.
His position was, "Go for it all. Go for the big one. Go to North Carolina."

Coach Smith would challenge you mentally. I remember my first mistake. I went baseline and tried to do a reverse move, and he just yelled, "Where do you think you are? Do you think you're back at E.A. Laney High School? You're not. You're in college. Do you think that was a good shot?" Obviously you can't say yes. He made you think. He never cursed at anybody. He was the perfect guy for me. He kept me humble, but he challenged me. He gave me confidence by giving me compliments when he thought I needed them.

But I was totally afraid of Coach Smith, because he was a big name in the state of North Carolina, and I was this kid from a small city. I never even thought about calling him anything other than Coach Smith. It was intimidating the way he controlled practice. I have never seen practice controlled the way it was at North Carolina. Every minute was thought out. If a drill was supposed to end at 3:10, it ended at 3:10, and the next one started. I never thought he was the kind of guy to get down on the floor the way he did in practice. He screamed and yelled. He never did that in a game. I was shocked at how he got into practice, how he controlled every minute, how he taught. They made practice challenging, which was right down my alley. They made it fun to learn.

When I got to North Carolina, there had only been four freshman starters: Walter Davis, Mike O'Koren, Phil Ford and James Worthy. I just wanted a chance to get out on the floor and make an impact. I'm listening to what the coaches want, and I'm competing my ass off. I'm trying to impress all of them. I'm not trying to con anybody. I'm competing, and I'm trying to earn the highest accolades. I wanted them to know that I listened, that I applied what I was learning, that I worked hard every single day. I wanted them to know I would be the first guy onto the floor and the last one to leave.

COACH SMITH *What you saw in Michael was his work ethic. He would compete in every drill. I'd seen other great athletes, but Michael also had the intelligence, the court savvy.*

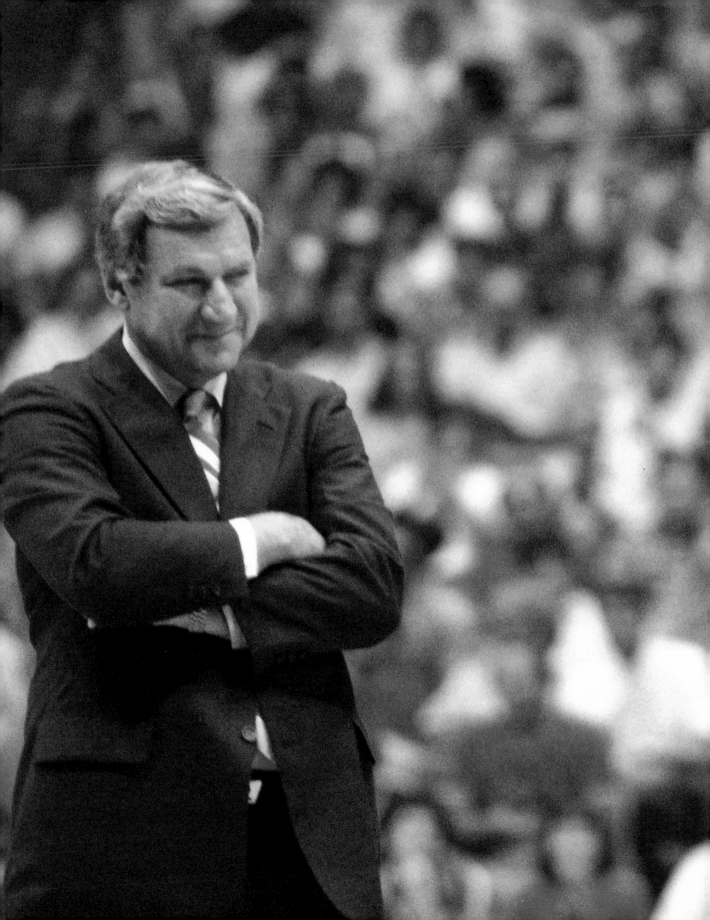

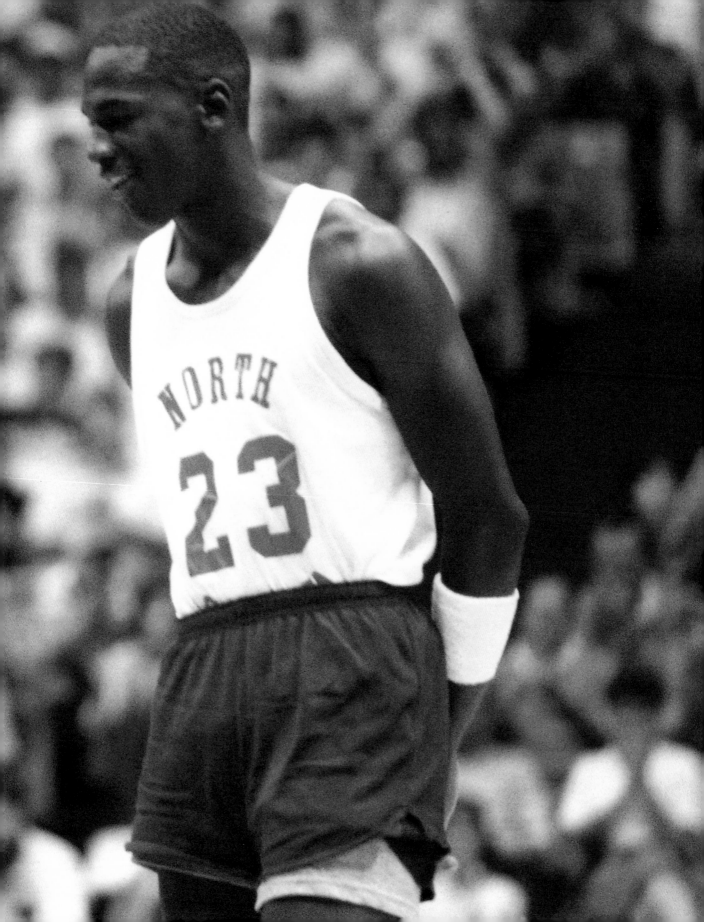

Sports Illustrated

The Year in Sports

2003

ONE FOR THE AGES

So Young, So Good . . .

NCAA Champ
And NBA Phen
Carm
Anth
AG

I CAME TO CHICAGO
WITH NO EXPECTATIONS.
NONE.

**THE ONLY PRESSURE I FELT WHEN I WENT TO THE NBA WAS
TO PROVE I DESERVED TO PLAY ON THAT LEVEL.**

And that was easy because it was a step-by-step process: playing hard
every day in practice, playing against veteran teammates, making the
starting five, then playing against NBA players in games. No one knew
what I was capable of scoring, and no one tried to define me by putting
a number to those expectations.

No one had in mind what would be acceptable for me. After the first year,
the expectations came, but by that time I had positive habits. I had built
a foundation for my game, so it wasn't a surprise to me.

**I UNDERSTOOD THAT THE REASON I WAS GETTING ATTENTION
WAS BECAUSE OF THE WORK I HAD PUT IN UP TO THAT POINT,
NOT BECAUSE OF WHAT I HAD DONE TO MEET OTHER PEOPLE'S
EXPECTATIONS FOR ME.**

ROD HIGGINS
*YOU COULDN'T HELP BUT NOTICE THIS GUY WAS
DIFFERENT FROM ALL OF US WHO WERE ALREADY
THERE WITH THE BULLS. HIS PRACTICE HABITS
WERE UNMATCHED.*

*That's what stood out right away. He comes into the first drill, and usually
a rookie has to feel his way through. Not Michael. I don't think he ever
had the mindset of feeling his way through. Whoever was in front of
him, Michael was trying to beat that guy. It didn't matter who it was.
He didn't say a lot initially. But his level of effort, his level of competing
stood out. Then the physical attributes were evident. It was right in your
face—he couldn't see any other way of playing. He always wanted
to take it to the next level. If the other guys didn't take their effort up,
then Michael had no problem embarrassing them.*

GEORGE KOEHLER *You ever see* Star Wars*? Yoda is this little ugly thing,
but he's the Jedi Master. He's the guy who taught everybody. Everybody
went to Yoda for knowledge. When you sit around talking to any older
person who has lived their life to the fullest, they have great stories to
tell because they have had great experiences.*

MICHAEL IS YODA.
HE'S ALWAYS BEEN AN OLD SOUL.

*When I met Michael he was 21 years old, but he wasn't 21 to me. I was
29 at the time, but he was so mature at such an early age. That's probably
attributable to the education he got from his parents, the education he
got from Dean Smith, and then the Olympics with Bobby Knight. He was
more mature than the average 21-year-old kid coming into the NBA.
It's an inner thing with Michael. I'm still amazed at him, just like everyone
else, and I've seen the entire show.*

MOM *When it came time to go to Nike, Michael said he wasn't sure he liked their product. Mr. Jordan and I said, "Why don't you try all of them before you make a decision." So we had an appointment to go to Portland, and Michael calls me the night before the trip. He said, "I've made up my mind. I'm not going to Portland." Mr. Jordan got on the phone and told Michael he had to go. Then he handed me the phone, and I said, "Michael, when we pull up to the airport tomorrow, you better be ready to get on the plane. You are going, and you are going to sit and listen. Whether or not it's your choice, you always need to show respect and listen."*

I had so much respect for Rob Strasser, who was a Nike marketing executive at that time. He believed in Michael. The whole time, Rob and his group were sharing their storyboards, and telling us how Nike would make it all work. Michael sat over in the corner and would not say a word. Mr. Jordan and I just ignored him and carried on the conversation. We went to lunch, and Michael was still pouting. I just told Mr. Jordan not to pay Michael any attention if he didn't want to be a part of the conversation.

DAVID FALK *They had created a video of Michael to the song Jump. It was like an early music video. Strasser walks in, and he's wearing a thin tie. He's a big guy, and he can't get the VCR to work, so he's just dripping sweat because his boss, Phil Knight, is about to come in. Michael's got his business face on because he's not prepared to like the presentation.*

I WATCHED MICHAEL'S FACE THE ENTIRE MEETING, AND HE NEVER TWITCHED A MUSCLE.

I was convinced he was either mad because he didn't want to be there, or he thought the whole thing was hokey. So everything moves to the second phase, and Phil comes in. Everyone knew Michael liked cars. At a key point during the presentation, Strasser tells Michael that these come with the deal, and he reaches into his pocket and pulls out two little model cars. Knight literally has his hands over his heart, because to that point guys were making like $10,000 an endorsement. He thinks Strasser is about to give Michael the keys to not one, but two Mercedes. We all cracked up.

It was a really early, high quality marketing presentation. Nike got it, and they delivered a coordinated line of athletic apparel and shoes. I asked Michael what he thought, and he said it was awesome. I would never have guessed that would be his response. I would have sworn he hated it. He didn't want to see anyone else, and he never did.

I DID NOT WANT TO GO TO THE NIKE MEETING.
I DIDN'T KNOW NIKE.
I DIDN'T THINK I LIKED NIKE.

HOWARD "H" WHITE *I walked up to this meeting, and there was Mr. Jordan, Mrs. Jordan and Michael. Everybody else at that meeting was white. We all kind of hit it off. I saw they wanted something true and real for their son. It was a leap of faith on both sides because Nike was presenting something that hadn't been done before. At the time, Michael loved Adidas. He wore Converse all through college. Nike was pretty foreign to Michael. The fact is, all Adidas had to do was come close to what Nike proposed, and Michael would have gone with them. They wouldn't do it. Converse told Michael they had a line of players, and he'd have to wait. It was amazing how it all came together.*

You can talk about the grand scheme and the grand design, but here was a guy who really wanted to be somewhere else. Finally, when it was all said and done, it just manifested. I don't know how you reproduce that kind of thing. Michelangelo and the Sistine Chapel? I'm sure somebody could do that today, maybe even far better. The brushes would be better. The paint would be better. But would it be the Sistine Chapel? I don't think so.

THERE IS SOMETHING THAT HAPPENS WHEN SPECIAL PEOPLE COME TOGETHER THAT TAKES IT ALL TO ANOTHER LEVEL.

You can't do an analysis and put those pieces together. You can't draw it up and execute. It's not the nature of greatness. It's like Phil looking around the Nike campus and saying, "Yep, this is exactly how I saw it all coming together when I was selling shoes out of the trunk of my car." No, that's not how it works.

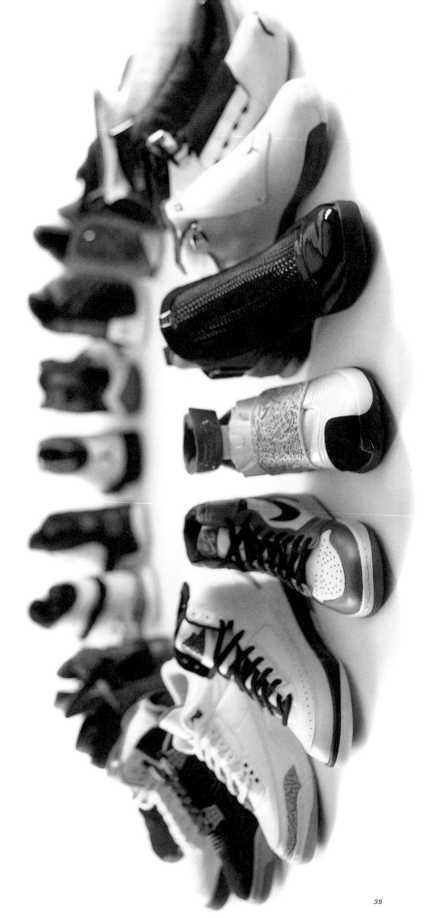

35

DAVID FALK It was like pre-Columbus. We were saying, "Hey Phil, the world is not flat." It's not that I knew the world wasn't flat. I didn't know. But I didn't think it was. It's so hard to take people back and have them understand that Nike's goal was to have sales of $3 million four years down the road. The environment was so completely different then.

THE ACCEPTED KNOWLEDGE WAS THAT A TEAM PLAYER COULD NOT BE MARKETED AS AN INDIVIDUAL. MAYBE A TENNIS PLAYER COULD DO IT, MAYBE A BOXER, MAYBE A GOLFER LIKE ARNOLD PALMER. BUT A TEAM PLAYER? NO WAY.

When the first shoe came out, Rod Thorn, the Chicago Bulls general manager at the time, called me. He said, "What are you trying to do; turn this guy into a tennis player?" That's exactly what we were trying to do. There was a time in the 1960s and 1970s when you had groups like the Supremes. What happened? People said it really isn't the Supremes. It's Diana Ross and the Supremes.

IT BECAME MICHAEL AND THE JORDANAIRES.

DAVID FALK

MICHAEL SINGLE-HANDEDLY TOOK TEAM SPORTS
AND CREATED A NEW HYBRID CATEGORY.
IT WASN'T THE TEAM,
AND IT WASN'T THE INDIVIDUAL.

The Beatles had that kind of impact. They changed the way people wore their hair, impacted the clothes people
wore. Part of it was just the fact Michael was so transcendent. He changed everything single-handedly.
It's what Elvis did, or what the Beatles did. There have been a handful of people in a century who have done
what Michael did to the status quo. It was like breaking the four-minute mile. Nobody thought it could be done.

When I went to Nike, they were telling me about their air sole technology, which was very innovative. But to me, that wasn't as important as being close to the ground. I didn't want to feel like I was playing in high heel shoes because it would increase my chances of twisting an ankle. It might have been innovative, but to me it also seemed dangerous.

For runners, fine. They go heel to toe, heel to toe. But for basketball, everything's on the ball of the feet, going right, left, stopping, turning. I wanted to feel like a race car, close to the ground.

I WANTED MY SHOES TO BE LIKE A PORSCHE OR A FERRARI, SO WHEN I TURNED, THE SHOE TURNED.

I was going against what Nike was developing at the time, but I didn't care. I had to play with what made me feel comfortable. That's another difference between today's athlete and me. I wasn't going to agree to anything without investigating, dissecting, understanding what I liked. I wanted to understand what was possible. I also wanted to know why they thought that shoe was for me.

WHERE AM I
IN THAT SHOE?

I also didn't want shoes I had to walk around in for a week to break them in. I wanted something I could take right out of the box and play in them. So I'm telling Nike, "I know it's going to cost more money, but with the right leather I can play right out of the box." I pushed them every way possible because I wanted to know they were committed to me.

MONEY IS ONLY ONE KIND OF COMMITMENT.

—

DAVID FALK I took Michael's father, James, to Converse with me. The essence of their presentation was that they had something like 16 employees that stood 6-foot-6 and over, and that they were American basketball. They had Dr. J, Magic, Isiah, Larry, Mark Aguirre, Herb Williams, Bernard King. I told everyone the same thing: "Don't ask what Michael can do for you, if you can't figure it out after what he did in the 1984 Olympics." I wanted to know what they were going to do for Michael. As simple as that sounds today, it was a great challenge in 1984.

Converse basically said they would do what they had done with Dr. J, Magic and Larry. And James, in one of the funniest low-key lines, says, "Don't you have any new creative ideas?" Here's a guy who didn't go to college, who had a lot of native intelligence, and after one month figured out these guys had the imagination of a wall.

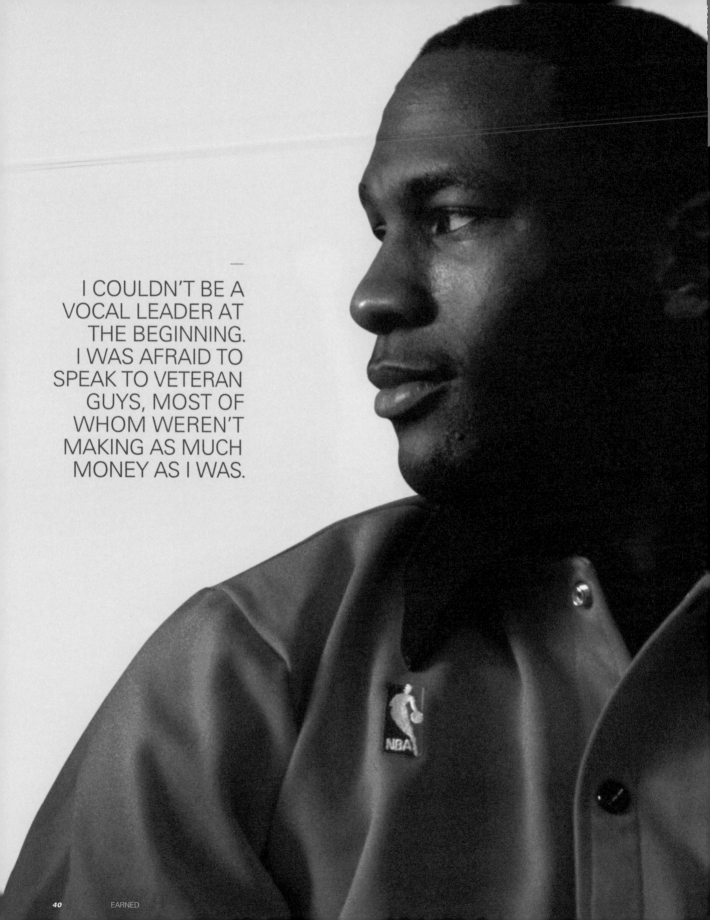

I COULDN'T BE A VOCAL LEADER AT THE BEGINNING. I WAS AFRAID TO SPEAK TO VETERAN GUYS, MOST OF WHOM WEREN'T MAKING AS MUCH MONEY AS I WAS.

They had to have a level of envy to start with. So I felt I had to be very cautious. My leadership came from action, all action. I had to pick my friends very carefully, like Rod Higgins. He was and still is to this day a great friend. I could never be good friends with Orlando Woolridge or Quintin Dailey because I was stealing some of their thunder. But I was doing it with effort and work. I wasn't asking for anything from anyone. My practice habits were great. I forced those other guys to improve their practice habits. I challenged them because [Bulls coach] Kevin Loughery challenged me. At the end of practice we would scrimmage, and the losers had to run. We'd be killing the second team, and Loughery would stop practice and put me on the second team. We'd still come back to win. Those were the things the other guys started to learn.

———

HOWARD "H" WHITE *If "The Guy" is going as hard as he can, what excuse can you have? If this guy is going so hard that people are shoving, getting into fights, then what are you going to be? Tired today? Hurt today? It was an outward challenge: If you are going to play with me, you better come with everything you've got every single minute. Michael's a taskmaster, but look at the example he set. MJ is hard. But he's hard on himself first.*

———

Our third game of the season we were playing Milwaukee in Chicago, and they used to kill us. We were down nine points going into the fourth quarter. Everybody had just written off the game. Now, Loughery tested me the same way he had tested me in practice. He wanted to see whether I was going to apply that same energy level to a game that looked like it was out of reach. He started running everything through me, and you could feel the game start to change. The crowd started coming alive, and pretty soon nine went to six and six went to two. Next thing you know, we had the lead, and we ended up winning by six points.

THAT IS WHEN—I CAN HONESTLY SAY—I FELT LIKE I HAD EARNED MY STRIPES, AND THE CITY OF CHICAGO STARTED TO BELIEVE WE COULD CHANGE THE FORTUNES OF THE BULLS. NO GAME WAS OVER AS LONG AS I WAS PLAYING ON THE COURT.

———

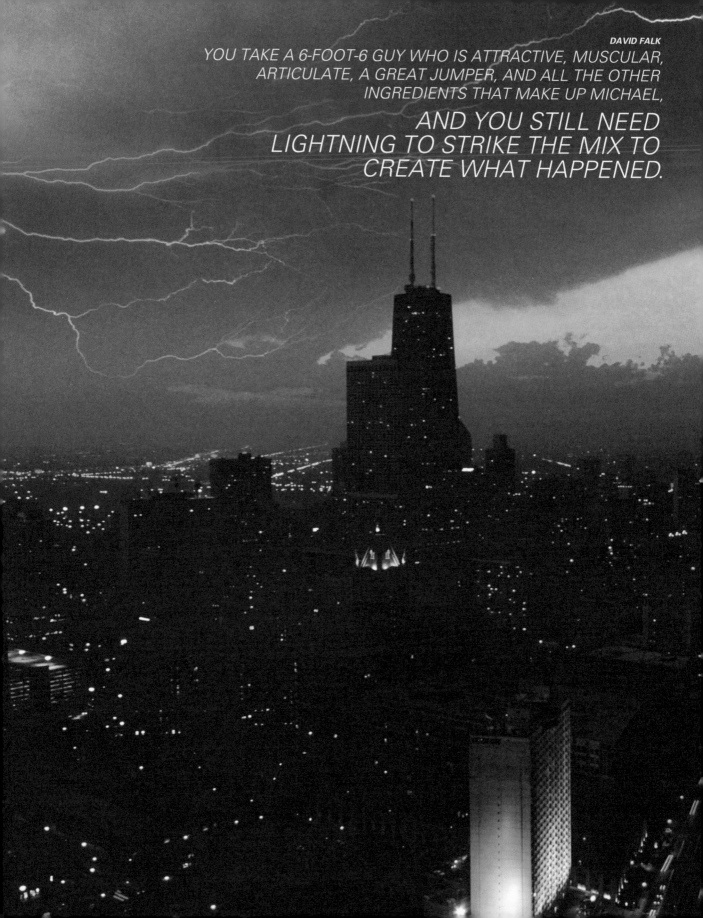

DAVID FALK

YOU TAKE A 6-FOOT-6 GUY WHO IS ATTRACTIVE, MUSCULAR, ARTICULATE, A GREAT JUMPER, AND ALL THE OTHER INGREDIENTS THAT MAKE UP MICHAEL,

AND YOU STILL NEED LIGHTNING TO STRIKE THE MIX TO CREATE WHAT HAPPENED.

DAVID FALK *I don't think it will ever happen again. I'm not saying there won't be a player who is better than Michael, but he came along in 1984 when the Olympics were in America, so he was on a worldwide stage. The NBA was coming out of its doldrums. There had been talk that six or seven teams could go bankrupt. Chicago, a major market, had been in the doldrums. Converse was at the top, but headed for a decline, Adidas was going through a transition.*

I think we had a good vision of what to do. Not a perfect vision, but we had a solid game plan.

MY BIGGEST REGRET IS THAT IT WAS ALL FROM SCRATCH. THERE WASN'T A MODEL WE COULD LOOK TO AND REFINE.

For example, Michael's first deal with Nike was for five years. Rob Strasser, who signed Michael at Nike, was nervous. What if Michael was a good endorser, but the line didn't work? No one had ever made it work in basketball to that point.

Rob wanted an option to get out of the deal in case it didn't work. We told him no, we weren't there to do a test drive. If you don't think you can do it, then don't sign him. So we compromised. They had the right at the end of the third year to stop making Michael's shoe. If he didn't make the All-Star team in any of the first three years, or didn't average 20 points a game—there were four or five performance categories— then Nike would have to continue paying him through the end of the contract, but they could stop making his shoe in the fourth and fifth year.

Then there was what I called a kickout clause. If Nike had bookings of $3 million for Air Jordans between the end of the third year going into the fourth, then even if Michael didn't accomplish any of the performance categories, Nike had to keep making the shoes in the fourth and fifth years.

THAT WAS NIKE'S GOAL: $3 MILLION IN SALES. THEY BOOKED SOMETHING LIKE $130 MILLION IN THE FIRST YEAR.

It was off the charts. We were asking a company to take an unprecedented step. In hindsight we probably erred on the side of protecting the downside too much. If we had asked them for $1 a year and 50 percent of the profits, Michael would probably be a billionaire. But we needed Nike to have enough money in the deal to motivate them to spend additional money on marketing to cover the investment.

The first Air Jordan shoe was the first time anyone had applied multiple colors.
When I first saw it, I said,

"I'M NOT WEARING THAT SHOE.
I'LL LOOK LIKE A CLOWN."

Peter Moore, who designed the first two shoes, told me to just look at the shoe.
"Put it on and look at it. Spend some time with it. If the shoe doesn't grow on you,
we'll change it." The more I looked at the shoes, the more they started to grow on me.

I told Peter, "Every time I wear these shoes in practice, my teammates come up
to me and tell me they are the ugliest looking shoes they have ever seen."
He says, "Guess what they are doing? They're looking at them. No matter what
they are saying, they are paying attention." That changed my whole perspective.
First and foremost, the shoes had to perform the way I wanted them to perform.
How they looked was a whole different issue, because you have to think about
marketing strategy. You want people to pay attention. If you see somebody walking
down the street in pink shoes, you are going to look at them. That's exactly
what happened with the first shoe.

I'M APPLYING THE SAME PRINCIPLES TO MY MOTORCYCLE TEAM.

The first year, we used Carolina blue on the motorcycles. In 2005, I went to Mark Smith and told him I wanted to change the colors to yellow, black and red. Mark is an unbelievably creative guy who works with Tinker Hatfield in Nike's Innovative Kitchen. I didn't care how Mark incorporated the colors or where the inspiration came from—those were the colors. The first designs were wild. In motorcycle racing, it's unheard of to put those kind of colors together. I looked at what Mark created and said, "I don't know, man. That bike looks like somebody wrecked it and then put it back together with whatever they could find: a yellow back, a black fender." I'm laughing because I know the kind of response it's going to get within the race community.

The riders told me they liked the Carolina blue a lot better, that the new colors would stand out. They said they looked awful. One of them said, "That's not what the Jordan brand is all about."

But they were wrong. What we did is exactly what the Jordan brand is about. It's about leading, not following. Sure, there are going to be critics, people who have been around motorcycle racing a long time who will be uncomfortable with a different design approach. I told them to do exactly what Peter Moore told me to do with the first shoe: Blow it up, put it on the wall and look at it for 45 minutes. Just look at it, take it in. But at the end of those 45 minutes, you are going to have everybody discussing and dissecting the designs, and we will have done exactly what we set out to do.

Now, the bike is still only going to do what you can do as a rider. Same with the shoes.

BUT THE WHOLE MARKETING APPROACH IS ABOUT DRAWING ATTENTION TO THE PRODUCT. ONCE THAT HAPPENS, AND EVERYONE PERFORMS THE WAY THEY ARE SUPPOSED TO PERFORM, THEN THE TWO COME TOGETHER LIKE A PERFECT MARRIAGE. AND THAT'S WHAT THE BRAND HAS BEEN: A PERFECT MARRIAGE OF STYLE AND PERFORMANCE.

Peter Moore and Rob Strasser took the absurdness of what shoes could look like, put them on Michael Jordan, and let him go out and play. Now those shoes had their own style and substance. Peter and Rob changed Nike's perspective by helping the company feel comfortable with the idea of being way out there, different, design leaders in the market. They helped push the company into the contemporary culture.

IN RETROSPECT, THAT APPROACH WAS AN ESSENTIAL PART OF THE PROCESS, THOUGH WE REALLY DIDN'T KNOW WHAT WE WERE DOING AT THE TIME. NIKE DIDN'T KNOW.

IT JUST HAPPENED, WHICH IS WHY IT'S SO DIFFICULT TO REPLICATE.

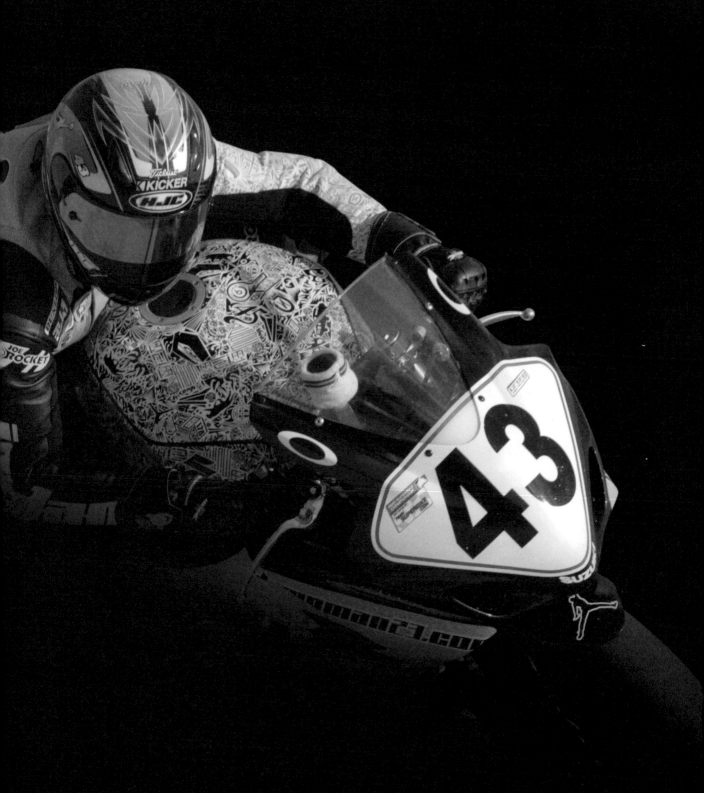

UNCOMPROMISED

*SOME PLAYERS LOOK AT ME FOR ALL THE WRONG REASONS:
MARKETING, ADMIRATION, MONEY MADE OFF THE COURT.*

They don't understand the foundation I had to create to support everything that came afterward. They don't know about lifting weights at 7 A.M., practicing hard every day, finding ways to motivate myself for every game, sitting up half the night with an ankle in a bucket of ice, or hooked up to an electronic stimulation machine. They don't know anything about those things.

*WHAT THEY DO KNOW IS THAT I HAVE MY OWN SHOE LINE,
AND THAT I DID MCDONALD'S COMMERCIALS.*

In a sense, my experience created a vision that obscured the hard work and commitment. With all the attention on the surface, it's easy to become confused about the source of money and glamour.

YOU HAVE TO BE UNCOMPROMISED IN YOUR LEVEL OF COMMITMENT
TO WHATEVER YOU ARE DOING, OR IT CAN DISAPPEAR AS FAST AS IT APPEARED.

Some players noticed me because of everything I was doing off the court, and that was the wrong reason to pay attention to me. Pay attention to the way I played the game. Pay attention to my passion. Pay attention to the idea of focusing on improvement every day. Pay attention to my commitment. Commitment cannot be compromised by rewards. Excellence isn't a one-week or one-year ideal. It's a constant. There will be days when you don't feel on top of your game, or meetings in which you aren't at your best, but your commitment remains constant. No compromises. No one on our Bulls teams ever missed a

month with a sprained ankle. We took precautions against those kinds of injuries, and when they occurred we did everything possible to play through them. We were going to be the best every night we stepped on the floor. That approach created an atmosphere and expectation that every player and coach understood.

LOOK AROUND THE LEAGUE TODAY, AND YOU SEE PLAYERS MISSING WEEKS OF GAMES WITH ANKLE SPRAINS.

YOU DIDN'T WANT THE ABUSE THAT CAME WITH MISSING GAMES ON THE BULLS. WE HAD A SHARED COMMITMENT TO THE UNIT.

Dennis Rodman could do whatever he wanted to do off the court and away from the team because he knew once he came back into the group, he had to plug into the team.

My sense of commitment extended beyond the game of basketball. The Jordan brand has continued to grow because we have remained uncompromised. It's easy to go the other way, though. It's easy to rest on your laurels, or to get fat on success. I don't ever want to get fat that way.

When our motorcycle team made it to the podium for the first time in early 2005, I celebrated that night with the rest of the team. We toasted our success and talked about how far we had come, especially for a non-factory team. But the next day I sent everyone a letter. I wanted them to know I was proud of what we had accomplished, but it was time to move forward.

Look around, and just about any person or entity achieving at a high level has the same focus. The morning after Tiger Woods rallied to beat Phil Mickelson at the Ford Championship in 2005, he was in the gym by 6:30 to work out.

NO LIGHTS, NO CAMERAS, NO GLITZ OR GLAMOUR.
UNCOMPROMISED.

SOME KIDS LIVE
DOWN TO
THE EXPECTATIONS.
ATHLETES,
EVEN PROFESSIONAL
ONES, DO THE
SAME THING.

Now I had some tough years in there, just like a lot of kids. Ninth grade was the toughest year of my life. I was 15. I was suspended the first day of school because I walked across the street to pick up something to drink. I had to go home and tell my parents that on the first half day of school, I got suspended. I had perfect attendance from grades 1 through 8. I had eight of those certificates. Not only had I never missed a day of school, but I became the first one in the family to miss a day, thanks to that suspension. That didn't go over too well, particularly when I already knew my parents were worried about me making anything of myself.

I had a job that summer for a week before I quit. Hotel maintenance. My mother was furious because she had talked one of her bank clients into giving me the job. They had me cleaning cigarette butts from the pool, and all my boys kept driving by blowing their horns.

——

MOM I knew he didn't want to work, but I made sure this man gave Michael a job. Every day he came home complaining. I said, "You're going to work tomorrow." The last day, he walked all the way home. I said, "How did you get here?" He said, "Please don't make me go back there. Make me do anything else, but don't make me go back."

It was all about learning that there were choices and responsibilities. Now how are you going to make those choices? Are you going to stand on the corner waiting for somebody to give you something? Or are you going to earn it and deserve it so no one can say you took anything without earning it? Those words went with Michael onto the basketball court. I told him not to wait for anybody to give him anything. Work hard so when you get the gifts, they are yours.

——

In ninth grade it was like trouble was nailed to me. The first suspension was because I didn't read the student handbook. Nobody gets to school the first day and reads the entire handbook. So I didn't know you couldn't go off campus. The guy said, "Now you have enough time to read it—three days." That just fueled it all. From that day on I just didn't like the school. I felt like they really didn't give me a chance. If you suspend me the first day, you really don't want me around. Now this was right at the time *Roots* was on television, and my parents made all of us kids watch it. I was rebellious.

I was suspended again, this time for cursing out a teacher. The last suspension, my mother locked me in the car with the window down about an inch. That's child abuse today. She parked right in front of the bank's teller window where she worked so she could watch me. I couldn't get out. Most dogs would die. She dared me to open up that door. By the end of the year, I was just trying to stay out of trouble.

I HAD SEEN THE LIGHT.

All that rebellion was out of my system. That spring I was playing baseball. The coach was really trying to be helpful, so he got me out of class early so I could help him line the field for that day's game. Now I'm minding my own business, putting down this perfect line from the right-field fence to home plate. I see these guys out there smoking cigarettes, skipping class, and they start messing up my line.

I'm just thinking, "Oh, please don't do that." I go out there and tell him to stop messing with the line. The guy gets ready to kick his foot at the chalk, and before that foot hit the ground I was on him. And here comes the principal. He had to be watching me because by the time I threw the first punch, the principal had come running. The other guy started it. I finished it, and the next thing you know I'm suspended again. I couldn't wait for that school year to be over. I had a great sports year, but in everything else, I struggled.

Years later, I would go back and visit my old high school, and the principal—the same guy who gave me those suspensions—tells all these kids, "You should be like Mr. Jordan. When he was here, Mr. Jordan never got in trouble."

——

I didn't have another year like ninth grade until my second NBA season, when I broke my left foot and missed 64 games. The day I found out it was actually broken, I went home and cried. It was like a part of my life had been taken away, and there was nothing I could do about it.

—

GEORGE KOEHLER *Michael gets the cast off and he has no flexibility or mobility, and he says, "I have to go test this out." It was all atrophied. So we drive to the gym.*

Michael says,
"Come on, let's go play one-on-one."

I said,
"Michael, you just got the cast off an hour and a half ago. You're not supposed to even be on the foot."

Now he's literally limping. He's got one leg. He was so hungry to get back on the court. That eight weeks or ten weeks he was in the cast, Michael was like a caged lion. He would pace in the house. It was just tough to be around him because he wanted to get back, and nobody would let him. It was like a thoroughbred going to the finish line, and they were just yanking on the reins, trying to hold him back. So we start playing one-on-one. Now I played high school basketball, but I was terrible, I didn't even start. But all white guys can shoot, and I wasn't a bad shooter. It was, "Make it, Take it," and we were playing to 10. I think I'm winning 4-1.

I said to him,
"You can't be doing this stuff."

All I could think about was, "What if he hurts himself?" I make a shot and go up 5-1. So he tosses me the ball.

He goes,
"No more."

I said,
"What?"

He says,
"No more points."

I said,
"You've got to be kidding me, Michael."

So I go around him and go up to take a jumper. From nowhere, he comes up from behind and grabs it out of the air. Now I'm trying to anticipate which way he's going to go because I know he has one leg. My guess was not even close to what he did. I lost 10-5. I didn't score another point. Not even close. He was so quick, even on one leg. I got beat by a one-legged man. Even though he was Michael Jordan, he still had one leg. He probably could have put a roller skate on one foot, and it still wouldn't have mattered. When he said, "No more," it meant "No more."

MOM

THAT YEAR WAS ABOUT
LEARNING DISCIPLINE
AND PATIENCE.
HE KNEW WHAT HIS HEART WANTED TO DO,
BUT HIS BODY WAS TELLING HIM SOMETHING ELSE.
HE HAD TO LEARN TO WAIT ON THE BODY.
OH, IT WAS HARD.

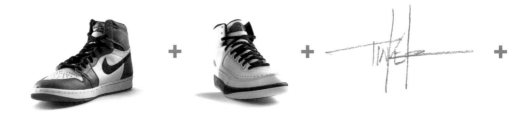

TINKER HATFIELD *The first two Jordan shoes really weren't designed very collaboratively, at least compared with how Michael and I would work together later. The first one wasn't even designed for Michael. It was a shoe in the basketball line that had been re-colored with the "wings" logo stuck on it. The second one was an industrial design project. It was by Bruce Kilgore and Peter Moore, and built in Italy, so Michael had little interaction with that one, as well.*

By the time the Jordan III came along, Peter Moore, the lead designer on the initial Air Jordan products, and Rob Strasser, who brought Michael into Nike, had left the company, hoping to lure Michael away with them. I'm sure they had it in the back of their minds that if things didn't go well with the design process of the Jordan III, it would be easier to get Michael.

The fact that Michael was coming off the broken foot his second season didn't help matters. My office was right next door to Peter's. He was a bit of a reluctant mentor to me. But he was a brilliant guy, really bright. Peter had this interesting stack of sketches, and you could just see that he had spun his wheels on the third shoe. He actually waited until it was too late to execute the Jordan III. I can remember this as clear as yesterday. Peter calls me into his office. He says,

"YOU DO IT. DESIGN MICHAEL JORDAN'S NEXT BASKETBALL SHOE." A WEEK LATER, PETER WAS GONE.

I was thrown into the middle of this highly charged political environment. Phil Knight was upset. Peter and Rob were making a play for Michael to leave Nike. Michael didn't know me at all. But after meeting with Michael twice, it became very obvious to me that he was design savvy. I had figured out he was into suits, and he was buying really nice Italian leather shoes. So I had a sense of his style.

I WANTED HIM TO THINK LIKE HE WAS A DESIGNER ON THE PROJECT, AN EQUAL PART OF THE TEAM.

He was able to talk on a very high level about inspiration, performance and his own personal interests. He was able to speak very clearly to all the things a designer would want to understand. I remember listening to him and saying to myself, "This is going to be great."

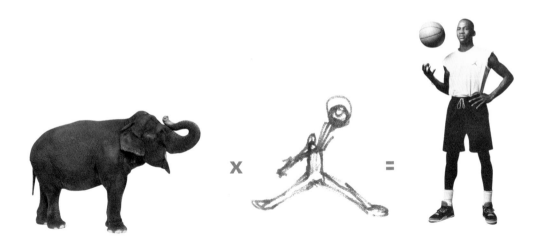

The two previous shoes basically had been hi-tops. Michael asked about doing something in between a hi-top and a low-top. He knew it would be great because the shoe would be light and still have a little more stability than a low-top. That was a performance thought, and you don't normally get that from an athlete. They don't always make great coaches, and they certainly don't make great product designers.

OBVIOUSLY MICHAEL DEMONSTRATED A LITTLE MORE CAPACITY.

One of the things Peter left behind in his stack of sketches was the Jumpman. Someone outside Nike had taken a photograph of Michael doing his spread-eagle dunk. Peter had a poster made of that shot with Michael in Air Jordan apparel. He traced the shot, modified it a little bit and created the Jumpman logo. But it had never been used on product.

WITHOUT DISCUSSING IT WITH MICHAEL, I INCORPORATED THE JUMPMAN INTO THE SHOE DESIGN.

We found some fake elephant skin that looked sort of like it was embossed. The "New Buck" material is almost like a suede. It is embossed and buffed so that the leather looks like elephant skin. I put that onto the shoe, along with some really beautiful material that we call floater, which is a leather that has been tumbled for a long period of time. When they tan leather, it is processed so much that the original wrinkles of the animal are eliminated, which is why leather is smooth. But that's not really the way the original animal skin looks. So when it's tumbled, the leather gets its wrinkles back. Those wrinkles can be enhanced, but the leather becomes a little bit softer and weaker in the process. That's why it had never been used in athletic shoes.

So I used the leather, the elephant skin, applied the Jumpman, made up a sample of the actual shoe, and then sketched up some apparel using some of the same elements. Ron Dumas, another designer, took the sketched ideas, refined them and made it all work. We developed the whole line in a matter of weeks. No one slept for days.

FRED WHITFIELD Rob and Peter were going to create an entire company for Michael. They already had an apparel company they called Van Grack. And they even had a shoe designed. They made a hell of a presentation. I'll never forget it. We were all there—MJ, his mom and dad—at Michael's townhouse. I know Michael had a lot of respect for Strasser and how smart he was. Same for Peter Moore, who was a design genius. It would have been a lot of risk for Michael, but they laid it out there.

At the time, we were looking at the upside. It could be our own little company. We could generate more income, have complete control, and still be on the cutting edge creatively. Rob had been in a power struggle internally at Nike. He was the guy from the beginning who was innovative enough to do the original Air Jordan shoe. Once that became successful, Strasser was the one who kept pushing to grow the line. So when my contract was coming up, he came to us and said,

"LET'S GO OUT ON THE EDGE. LET'S DO SOMETHING DIFFERENT. LET'S START OUR OWN SHOE COMPANY."

Peter was our lead designer, and I had worked very closely with him. And Rob was a very good friend of the family.

——

DAVID FALK Michael called me after the meeting in Chicago. Over a period of time, Rob had laid out this whole plan for Michael to leave Nike. He was going to represent Michael, not just with the shoes, but everything. In addition to the shoes, the new company was going to handle all of Michael's marketing. I would say, in theory, it wouldn't have been a bad idea if something like that had happened right out of North Carolina.

But Michael was at Nike, and it was becoming the most successful endorsement in the history of professional sports. To say that I was in shock would be the understatement of the century. First, I thought Strasser was a really close friend, and to think he would have done all this behind my back amazed me. Second, it's the kind of thing that seems really sexy and exciting to a client because they're not seeing the downside.

I had a meeting with Michael's parents, who were very, very competitive. I said,

"YOU DON'T UNDERSTAND. THIS IS GOING TO BE LIKE WORLD WAR III FOR PHIL KNIGHT.

And Phil is a very competitive guy. This is his number one talent leaving, and he's not going to say, 'No problem, you have my blessing. Take my number one endorser. Good luck.'"

I HAD JUST COME OFF A VERY DIFFICULT YEAR.

I HAD TO FIGHT THE BULLS JUST TO GET BACK ON THE FLOOR AFTER I BROKE MY FOOT.

YOU COULD SAY I WAS GETTING MY BUSINESS EDUCATION. I HAVE NEVER BEEN AFRAID TO ASSERT MYSELF ON OR OFF THE COURT.

AND I WASN'T AFRAID OF CHANGE.

I SAW HOW THINGS COULD TURN. SO I WENT INTO THOSE CONVERSATIONS WITH ROB AND PETER WITH AN OPEN MIND.

TINKER HATFIELD *Michael was playing golf in California, so we all gathered there for the Jordan III presentation. Phil Knight is there. And he's scared to death because he knows Michael is thinking about leaving Nike. Both of Michael's parents are there. This is the biggest presentation of my life. My boss is sitting next to me, and I'm sure he's either worried about Michael leaving, or worried Michael won't like the design.*

A half hour goes by. An hour goes by. We're all sitting in a conference room with no windows. Another hour goes by, and you could see Michael's father starting to get a little steamed. Delores is cool. Phil is very cool. Finally, four hours after the scheduled start of the meeting, Michael walks into the room with Howard.

MICHAEL'S IN A VERY BAD MOOD. YOU COULD TELL HE DIDN'T WANT TO BE THERE.

Turns out he had been with Rob and Peter on the golf course for those four hours. They had come pretty close to sealing a deal with Michael. They told him there wasn't anyone at Nike who could do the kind of work they had done, that no one would know how to advertise or market him. Michael came into the meeting begrudgingly. He says, "All right, show me what you've got."

So I took him through our two previous meetings. "Remember when we talked about this? Remember when we talked about that? You told me how you wanted to play around with the height of the shoe." I let him know I took all that to heart. Phil Knight is sitting there listening, because he didn't know you needed to work with athletes collaboratively on all aspects of the design.

In those days I wouldn't show anything until I had set it up verbally. I had to prove to everyone in that room that I knew what I was doing. So I showed some drawings. "This is what I came up with as a result of our collaboration. Here is what I think the shoe could look like." All of the sudden, Michael started to warm up. He's making the connection between what we had talked about and a two-dimensional representation of our conversations. You could see him losing his edge and coming more into the meeting.

I told him we called in a few favors and that I actually had a sample of the shoe. He says, "You have a shoe already?" It was underneath a black cover. When I pulled off the cover, Michael just lost it—his bad attitude disappeared. He got a big smile on his face. He grabbed the shoe.

AT THAT POINT, HE REALIZED THE SHOE WAS HIM. IT WAS PART OF WHO HE WAS AT THAT MOMENT.

The Jumpman, which until that point Michael had only seen in poster form, was now a logo on his shoe. I didn't put a swoosh on the side of the shoe, only on the back because I wanted him to know this was going beyond whatever Nike had done to that point. Then I brought out the apparel. Until that moment, Phil hadn't seen anything, either. I wanted the drama, though there was enough of that already. I wanted the impact. At that point in the meeting, Michael is talking a mile a minute about colors. He had completely changed.

*THE JORDAN III WAS DIFFERENT FROM ANYTHING THAT HAD COME BEFORE,
AND MY LIFE MIRRORED THAT FACT.*

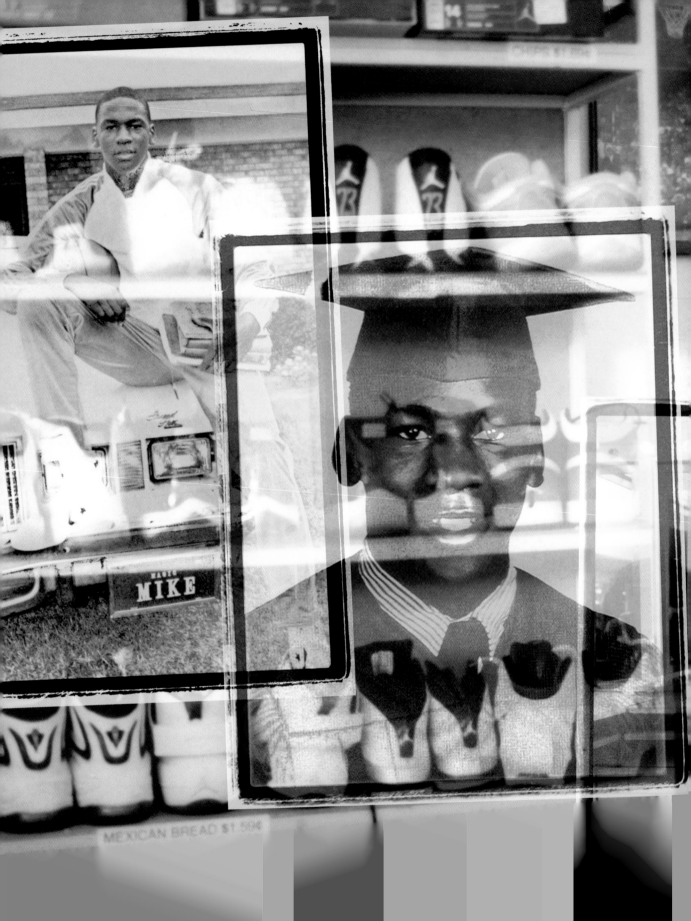

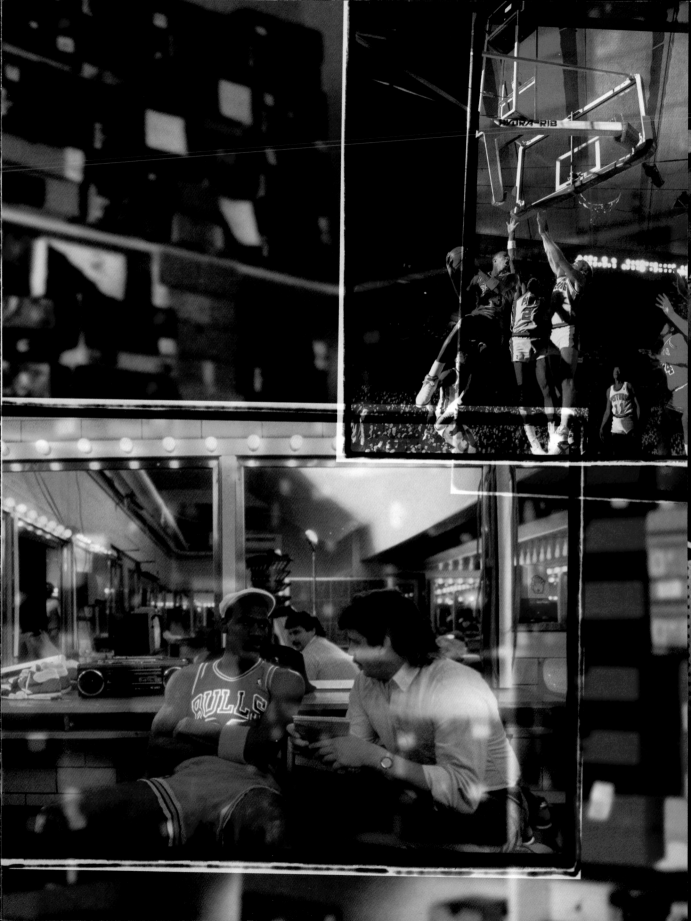

THE DECISION TO STAY AT NIKE ENDED ONE PERIOD AND STARTED ANOTHER. WITHIN 18 MONTHS, I HAD A SON, A WIFE, AND I WAS TAKING MY GAME TO ANOTHER LEVEL.

HOWARD "H" WHITE We all know how competitive Michael Jordan is. Nike is an extraordinarily competitive place. Phil is a pretty competitive guy. Nike wanted to take over the world. Michael wanted take over the world of basketball. So that drive was mirrored from one to the other.

Michael is by the numbers. You tell him, "Michael, you could do it this way and get there quicker." But Michael has never believed in shortcuts. He's not interested in getting there quicker if it's not the right path. He's going from point 1 to point 10 in order. He only knows one way to do anything, whether it's practice, a game of basketball, ping pong, dressing—he brings everything he has to the table every single time he sits down. And that's what he did at Nike. Nike was a place doing things exactly the same way as Michael.

WHEN YOU SEE MICHAEL JORDAN, YOU SEE A MAN WHO IS NOW CALLED THE BEST EVER. BUT YOU ONLY SEE THE EXTERIOR. YOU SEE THE FORCE, THE BALD HEAD, THE LONG, LANKY BODY. BUT WHAT DROVE THAT MACHINE IS FAR BIGGER THAN WHAT IT PRODUCED ON THE OUTSIDE. THE DIFFERENCE IS THAT IT RESIDES INSIDE HIM. IT IS RELENTLESS.

So there was something for Michael to plug into at Nike. You could have the greatest game in the world, but if you had to plug into a place with no electricity, what do you have? When he came on board at Nike, there was something to plug into that helped light everything that has happened for both of them. They are parallel stories.

The shoes that you saw really represented who Michael was at that time. They were a reflection of his life as it was being lived. Nike wasn't trying to fool anybody. It really was Tinker Hatfield's interpretation of this individual. It was beautiful. Tinker and Michael became a family. They talked to one another; they would go out with one another. They believed in something, which was the spirit of this place, Nike.

TINKER HATFIELD In one of our more recent meetings, I asked Michael whether it was the design of the shoe that got him to stay at Nike. I just wanted to know what really turned the tables toward Nike. He said, "Well, it was great to see that shoe, but it was my dad. My dad said, 'Son, these guys can do right by you.'" He listened to his dad, and he listened to his own heart in terms of how the process had culminated in the design of a shoe that was like no other. That turned him on. To this day, Phil Knight thinks I helped save Nike that day. I don't know if it was true or not, but that's his perception.

Rob and Peter were talking about a startup, so there was no guarantee. My father was very street-smart, and he based his opinion on balancing a guarantee versus a non-guarantee. It didn't take a brain surgeon to take the money in front of you, instead of the money that might be down the road. I could have broken my foot again. It could have become a chronic problem, like Bill Walton's. I didn't have that sense, but no one knew for sure.

Nike put a big deal on the table that expanded our line, gave me more creative control and approval rights. Within Nike, it appeared we were expanding the line, when in essence we were starting another company beneath the Nike umbrella. Rob and Peter understood my feeling about the guarantee. They told us to use what they were trying to do to get what we wanted from Nike. And that's what we did.

MOM *I truly believe in commitment and integrity and honesty. We started with Nike. Maybe Phil wasn't there a lot in the beginning, but Michael was part of his company. Rob and Peter got their start at Nike. Phil had trusted them to be strong leaders. Now you see you can own a little more for yourself—Mr. Jordan and I didn't think that was fair.*

Even though Peter and Rob had been there, and we knew they had excellent skills, the stability wasn't there. The finances were not there. Building a corporation solely on Michael meant he had to be willing to give his time and commitment.

I TOLD HIM,
"YOUR OBLIGATION IS TO BASKETBALL, THOSE ARE YOUR SKILLS, THAT'S YOUR GIFT."

He was going to have to rely on somebody else to dictate every inch of the business, and I don't believe in giving anybody that kind of power. You can't do both—run a company and play basketball—and do both of them well. Nike had a corporation before Michael came along, and it had many resources. We were looking long term to when the ball stopped bouncing. I think we were just trying to help him make good solid choices for the long term.

I always wanted to know what successful people used when they were evaluating a deal or making a decision. I was with Coca-Cola early in my career, and they would put me on a dog-and-pony show all over the country to meet bottlers. It would take almost eight days. I'd go into supermarkets, everywhere, shaking hands.

On one of those trips I was in Omaha, Nebraska, and I had the opportunity to meet Warren Buffett. He invited me out on his boat. First of all, I don't like boats. Now this is the richest guy in the world, and he's the largest shareholder for Coke.

I said, "Mr. Buffett, I don't mean to offend you, but I'm afraid of boats."

He said, "Don't worry, we have lifejackets."

I told him, "You're going to have to give me two to get me on that boat."

He said, "This boat is not going to sink."

I said, "That's what they said about the Titanic."

I asked him about his decision-making process.

"Mr. Buffett, you are very successful, and obviously I have heard a lot about what you have done. What do you think about when you make decisions? What's your thought process?"

He says, "Not much. Whatever my gut tells me, that's what I do."

I thought that was pretty wild, because up to that point no decision I made had involved a lot of statistical analysis, or a lot of weighing of the pros and cons. I was just asking myself, "What do you feel?"

ONCE I MADE A DECISION,
I DIDN'T THINK ABOUT IT AGAIN.

It was strictly off gut. That's how I made the decision to go with David Falk; that's how I evaluated deals before I signed my contracts. If I thought the money was cool, great. I didn't think about it again from that point forward.

It's still amazing to me that given the decisions Warren Buffett makes, and the money that transfers with those decisions, that he still goes with his gut.

I JUST FELT GOOD HEARING THAT FROM A GUY LIKE HIM.

—

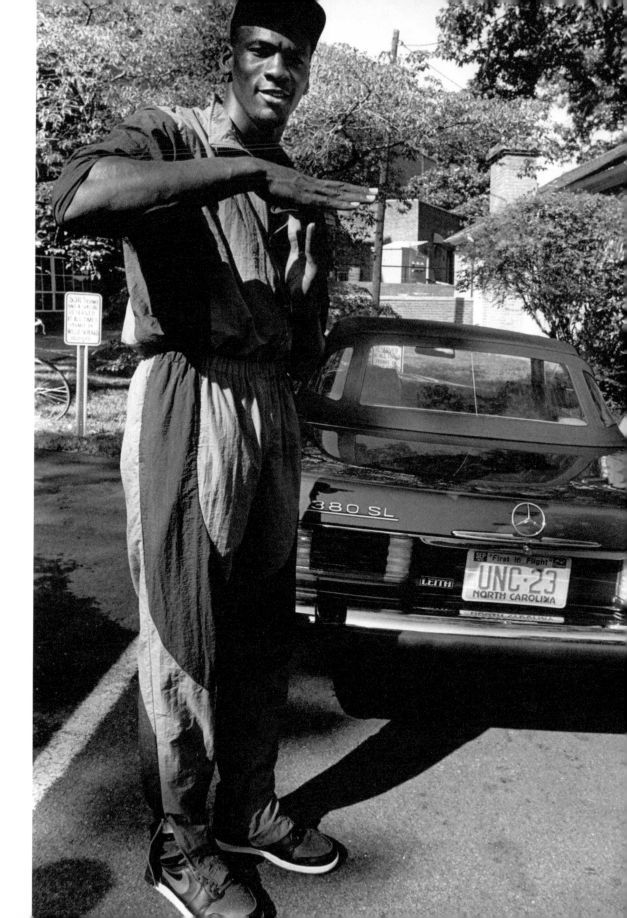

TINKER HATFIELD *One of the first times I met with Michael was at his townhouse in suburban Chicago. What I remember is that Michael was in the middle of a table tennis match with Charles Oakley. They were playing in the basement—one guy is 6-foot-6, the other 6-foot-9—and they could barely stand up straight. As Howard White and I walked down the stairs, we could hear them. It sounded like a wrestling match, with bodies flying. I thought they were going to fight. That was my first real introduction to the essence of Michael Jordan. I certainly didn't expect some second-rate townhome in the middle of suburban sprawl, but that's where Michael lived.*

There was nothing cool about it. I was really surprised by that, and maybe even impressed. He'd signed a huge contract with Nike, a big deal with the Chicago Bulls. He had scored 63 points in Boston Garden against Larry Bird, and he's still living in what was basically an average apartment. I remember thinking, "That's kind of cool. He's not too big-headed or full of himself."

Years later, Michael talked about how he had been taught by his dad, and later Dean Smith, that you needed to earn everything in life. Even his first house after he got married was a normal place. It wasn't anything special whatsoever, and he was a major superstar by then. That's an interesting aspect to Michael.

I've always been very conservative financially. That came from my advisors, and I listened to them because I was scared. My parents always told me, "You don't want to waste everything you have made. You don't want to be like some of these guys at the end of their career with nothing to show, looking for work." Now that was scary for me, the idea that at some point in time I would have to go get a job.

ROD HIGGINS *One day, another Bulls player, myself and Michael went to lunch. Michael ordered his meal, and he knew exactly how much it cost. The bill comes and it is $70 or $80. Michael says, "Here's my $15 plus tip."*

The other guy says, "No, we're splitting it three ways." Michael says, "No way. I ordered $15 worth of food, and that's all I'm paying. I'll break out the calculator." The dude actually broke out a calculator one day when we were eating lunch. The other guy, our teammate, got so upset they were about to fight. The guy thought Michael was trying to show him up. Michael said, "Fine, we'll be two fighting guys right here in this restaurant, but I know one thing: I'm putting down $15 plus tip on this table, and I'm done. I didn't order those shrimp cocktails."

He was very frugal. He knew he was going to be making a lot of money for a lot of years, but he was not about to spend it before he earned it. He never took money for granted. His parents were hard-working people. Michael definitely paid attention.

Initially, yes, I had those urges. I bought a fur coat, some things like that. After you get over the idea that you have some money, and you have the right people around you, you start to understand what's excessive, what's reasonable, what's needed, what's not needed. I was blessed with that supporting cast. I wanted to feel like I earned the money before I started spending it. I'm still aware of what money is and what it means. I've seen a lot of people who had opportunities to be successful and wealthy, but they made critical mistakes. I live by example. I pay attention to those things. These days, we have a lot of kids who don't think about tomorrow, or what could happen. That's how they have been brought up. If they don't have an understanding of what could happen, then they better have really good support systems—and some of them don't have either. Money never drove me. Sure, I wanted to be successful. I wanted the nicer things that success brings. But my passion was pure. The way I played, and the way I go about things, has never had anything to do with money.

MOM *He still has a budget. He disciplined himself with money. He spends money here and there, but believe me, he has a budget. He knows how much he's going to spend, and that's it. I often told him about Joe Louis, the boxer. He died homeless. Didn't even have money to bury himself. No discipline. No direction. It's not how much money you have; it's how you maintain what you have.*

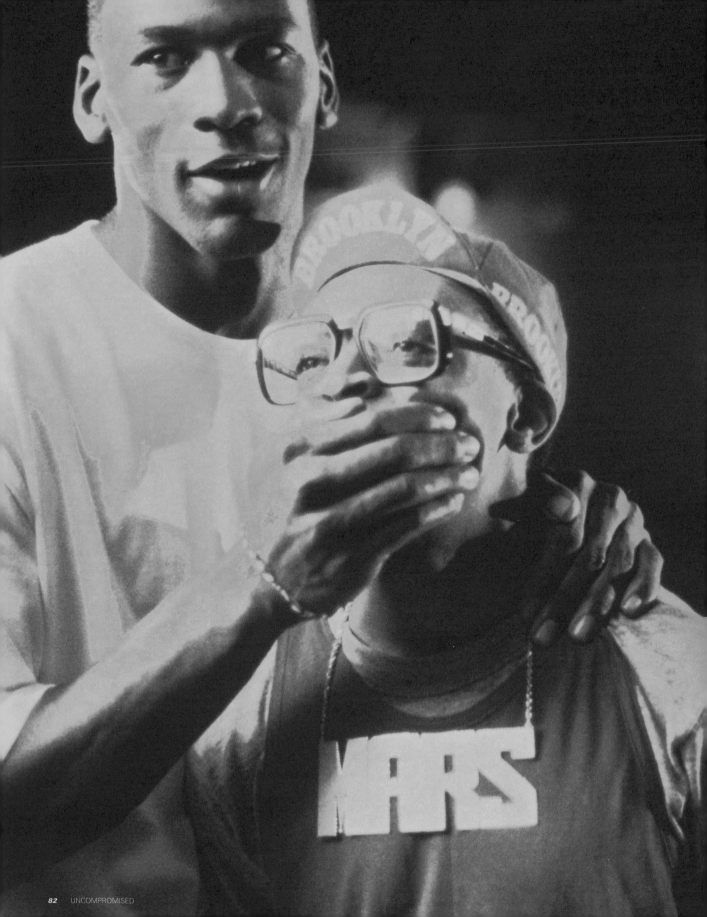

TINKER HATFIELD I got to know Jim Riswold of Weiden+Kennedy, and he started asking me how we were creating the shoes. I don't think that had happened before. The ad team never had any interest in how the whole design process evolved. Jim's approach and creativity became the fourth leg at the table.

When Jim came up with the Mars Blackmon campaign, it was like, "Wow."
MICHAEL'S GOT THIS GOOFY, COMICAL SIDE THAT IS IN DIRECT CONTRAST TO HIS VICIOUS, COMPETITIVE NATURE.

You have to be careful with him because he'll rip your throat out to beat you at a game of h-o-r-s-e. But it's pretty interesting how the two ends of the spectrum come together to create this guy.
—

When I was younger I didn't really fit in, so I was a jokester. Laughter always makes it easier to get in with a group.

I never take anything so serious that I can't laugh. I always felt that if I could laugh and joke around, then I could fit anywhere. Once I'm accepted, then I can show all sides of my personality. When I meet people, the first thing I want to do is make them laugh because it takes the pressure off for both of us.

Now they can be a little more at ease, and better understand who I am as a person. Laughter has always been the way people can get to know me, and it's the way I try to get to know them. It takes the walls down a little bit so the real person can come out.
—

TINKER HATFIELD

WHEN YOU DO SOMETHING THAT CATCHES THE HEARTS AND MINDS AND IMAGINATIONS OF PEOPLE AND IS REALLY SPECIAL—AND I'M SURE THIS IS THE SAME WITH WRITING A BOOK OR MUSIC—

WHAT DO YOU DO FOR AN ENCORE?

Sometimes the encore is harder than the initial body of work. To some degree, Michael has always had an encore. He has continually surpassed the expectations of others, no matter how demanding they had become. It's part of his appeal.

With the Jordan IV, I wanted to get further into performance innovation, which was essentially what Michael was doing on the basketball court. I mostly focused on the upper. The Jordan IV was the first time we used what is called an over-molded mesh. Most people would not spend a lot of money on a basketball shoe with a mesh panel. Even though it's a good idea, because it's breathable and makes the shoe lighter, it cheapened the shoe a little bit in the minds of some consumers.

I wanted the shoe to be lighter, with features no one had done before. So instead of starting with some kind of romantic story of Michael's life or something I saw him do, I started from a technical perspective. I couldn't do a normal mesh, so we dipped this mesh into a vat of soft plastic, then blew air through it to clear out all the plastic in between. So now the mesh was coated, and it became a design feature. We also developed a multi-port lace-locking system. I had invented what we called lace locks, and in the IV we did an elaboration on the theme. You could lace through any of nine ports, so you had 18 different positions. It was a little bit more of a technical story, and a little less of a personality story, but that's where Michael was at that time in his life. He was mastering different phases of his game as a player, and growing into these different roles of husband and father off the court. He didn't want this particular shoe to be too fashionable, because we had come out with the III with all the luxurious leather. This shoe was about getting back to work, being a little more utilitarian, while doing a couple things no one had done before. It reflected his state of mind.

HIS MINDSET WAS ABOUT GETTING BACK TO THE BASICS.

The decision to stay with Nike was behind him, but everything was ahead of him on the basketball court.

My father didn't believe you could rely on people to do things for you because they were not going to have the same passion for getting it done right. A great example: If something was broken in our house, my father would teach himself how to fix it. We had a one-level home. Now my father could have found an architect to draw up plans, and a builder to add a second floor onto our house. He did it all himself.

We went through certain winters with plastic up because my father was doing all the work. He'd come home after working all day, and work on the house. When he was done, he knew it was done right. That was him. That was the way he approached everything. His taxes? He understood everything about his taxes. He would work with the guy who prepared his returns, but it was going to be done the way my father wanted it done. That was his nature. My mother was the same way. How could their kids not have the same approach, be it in school, a job, or playing a game?

IT ALL CAME DOWNSTREAM FROM THEM.

MOM *Mr. Jordan tore a whole roof off the house. Everybody in the neighborhood thought he was crazy. But it's about having a support system. We were together. He knew I was there to support him. I said, "Of course, you can do it." If no one else believed in you, then I wanted everyone in my family to know I was there, and I believed in them. If you fell on your face, then you had someone there to pick you up and encourage you. That's family.*

HOWARD "H" WHITE *Michael is methodical. Same meal before every game, always a steak. I told him once, "You know, they're doing things a little different these days. Guys are eating a Cobb salad, nice spaghetti dinner." And he tried that. But he said, "In the fourth quarter, that's gone. The steak gives me fuel in the fourth quarter." Possibly. But remember the idea of "earned." That is what we were taught way-back-when, and he is an old-school, fundamental, by-the-books guy.*

THERE ARE NO SHORTCUTS. THERE IS NO WAY AROUND WORKING HARD. IT'S STRAIGHTFORWARD WITH MICHAEL.

He's not altering his approach to please you. And he discovered something about the game that wasn't about him. Winning became about everybody working. He believes that if everyone around him is willing to work hard, there will be rewards. That's the essence of greatness. I don't care if you are talking about Louis Pasteur, George Washington Carver, Alexander Graham Bell. There is something to going step by step by step by step. Michael has allowed himself a simplistic approach. Obviously he has made a lot of money, drives the greatest cars in the world, has a great place to live.

BUT DESPITE THE FAME, POWER, FORTUNE, HE'S STILL A VERY SIMPLE GUY.

Until the Jordan III, I had to walk around in the shoe and break it in a little bit before I could play. When my foot perspired, the leather expanded. By the end of the game, the shoe looked like I had been playing in it for 10 weeks. So each year we were looking for materials that had more stability, so that at the end of the game the shoe retained its structural integrity.

Nike started taking high-speed films of my feet as I played. They even dissected the shoe to see where my foot movements were weakening the structure of the shoe. It was fascinating to me, and Tinker was the force behind it all. We went to podiatrists to determine the stress points on my feet and where they were impacting the shoe.

NO ONE SAW ALL THE WORK WE WERE DOING AWAY FROM THE GAME.
THEY KNEW ABOUT MY WORK ETHIC, THE WAY I PRACTICED, HOW HARD I PLAYED, THE FACT I WAS ALWAYS TRYING TO IMPROVE MY GAME.

But it didn't stop in the gym. Sure, I was interested in the style of the shoe, and I wanted everyone to be able to see my life in each shoe. But more than anything, I needed the shoes to work for me on the floor. If my performance could be positively affected by the way the shoe was built, then I was willing to listen to every idea. From that standpoint, we weren't just making a shoe that looked good. It was always about performance first.

—

TINKER HATFIELD *The Jordan III had an interesting new approach, and the IV was a little bit of a reversal back to utilitarian technical design. So with the fifth shoe, I wanted to do something that not only added technical elements, but had a style of its own—again matching up with Michael. We put clear rubber into it and added flames so the shoe had this fighter plane story. It also was the first time anyone ever molded foam into a shoe upper.*

I had designed the shoes Michael J. Fox wore in Back to the Future II. *There was clear molding that allowed the light to come through, which got me thinking about making a clear rubber outsole.*

A LOT OF PEOPLE CALLED THIS THE GLASS-BOTTOM SHOE.

It was the first basketball shoe that had a clear outsole. We actually used reflective material on the huge tongue, so anytime there was a flash of photography or light, the Jumpman would produce an explosion of light.

This was meant to be kind of like coming out again, not only with the performance aspects, but with showy, interesting features. The reflective tongue, glass bottom, flames, molding—it had so much going on. And so did Michael. The shoe came out in February 1990, and Michael was a complete player. The team was on the verge of a championship, and he was in between his first two Most Valuable Player awards.

BEFORE I EVER PUT PEN TO PAPER ON THIS ONE,
I THOUGHT ABOUT HOW HE PERFORMED LIKE A FIGHTER PLANE.

He would be floating around the edges of the game and come out of nowhere to attack. The British Spitfires and American fighter planes from World War II had nose art on them. The pilots would paint flames or tiger teeth as a way to frighten the enemy a little bit, but also to individualize their efforts.

As I worked through the design of the shoe, I thought I'd try to make it look a little bit like a fighter plane. Not literally. I don't like to do literal translations, but more subtle suggestions that this shoe is aggressive. I actually reversed the nose art because, sometimes before Michael would start his move to the basket, he'd fake first. So it was actually about stopping before the other guy could stop. The developers were all irritated because it was so difficult to create a midsole that had flames on it. We literally didn't know how to do it at the time.

I'm very secure in my ability to focus on what I want. If I have an agenda or a goal, no one is going to deter me from what I want to do. When I'm trying to make a statement or prove something, I might joke around with you, but don't confuse that with changing my motivation.

I'M STILL GOING TO GET UP AND WORK OUT IN THE MORNING, AND DO THE NECESSARY THINGS. IF YOU HAVE SOMETHING ELSE YOU WANT TO DO, FINE. I'LL CATCH UP WITH YOU. BUT I AM NOT GOING TO BE TALKED INTO LOOKING THE OTHER WAY.

When I got to a point where I was a senior partner on the Bulls, the guy who had been there the longest, I started to exert my leadership vocally. I guess you could say I became a tyrant, or at least that's how some people chose to interpret those actions. That's not how I viewed it.

I knew what it took to come from where we were in 1984. I had put in the time, and I had earned the right to let my teammates know what I expected of them. And it was no more than I expected of myself. I played in front of 8,000 people a night in the beginning, and that never determined how hard I played. It's easy when 18,000 show up, and every game is sold out. It's not hard to find your motivation in that environment. I was playing when the Stadium was half empty, and my effort was exactly the same. If you can't play in front of a full house, then you have to get the hell off the floor. I don't know what motivates you if that doesn't do it.

—

ASPIRATIONAL

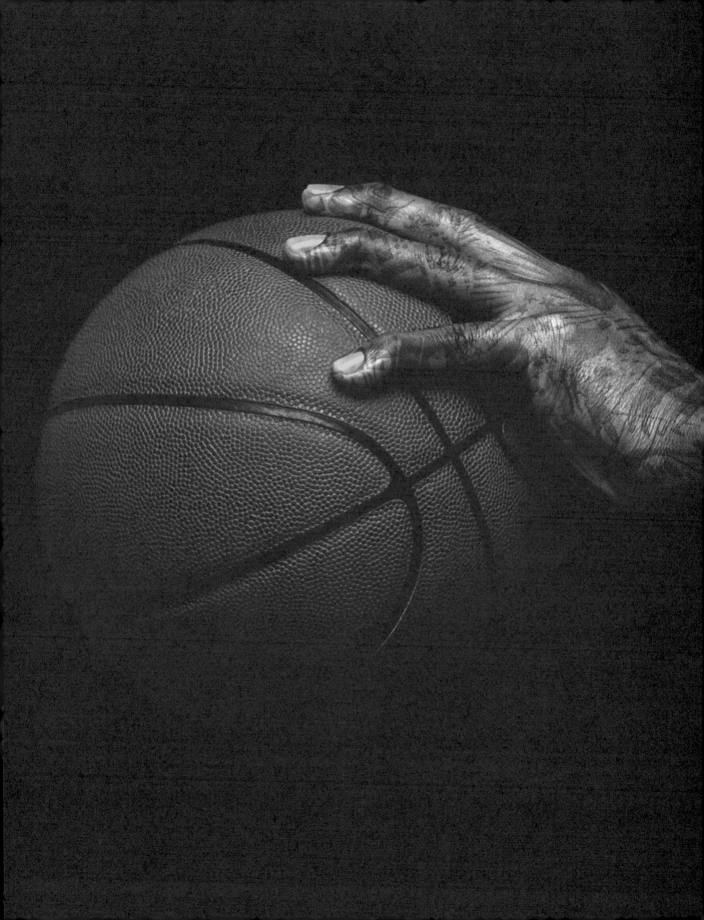

ALL I KNEW IS THAT I NEVER WANTED TO BE AVERAGE.

Whatever I was going to do, I wanted to do it my way. I just wanted the freedom to express myself. It wasn't about trying to be different for the sake of being different. I just wanted to follow what I felt. My father put a challenge in front of me. I knew what he expected, but I expected even more. The expectations I had for myself were beyond my father's expectations. My thoughts were way beyond the idea of preparing myself for a job so I could be like the guy down the street.

I HAD DREAMS. THEY WERE MY DREAMS, AND I HAD NO FEAR OF THEM.

I knew I was going against the grain a fair amount of the time, but I came to realize that was just part of the process. I know my parents worried about me amounting to anything, much less someone whose dreams extended beyond Wilmington, North Carolina. But I wanted to become more than a slightly better version of somebody else.

I WANTED TO APPLY MY CREATIVITY TO EVERYTHING I DID.

I wanted others to see me as I saw myself. Fear of failure? Why would I have any? I didn't know where my dreams would lead. I had dreams, but I didn't have all the pictures, because they didn't exist. So I could push ahead with my eyes wide open, take in whatever happened, and move on. I wasn't limited by someone else's view of how my dreams should look, or whether they were reasonable or not.

I COULDN'T HAVE IMAGINED EVERYTHING THAT HAS HAPPENED.
BUT DREAMS ARE LIKE THAT.
THAT'S WHAT MAKES THE JOURNEY SO INTERESTING.

Put all the work in, and then let the future emerge. It's what I did on the basketball court. I let the game come to me before I imposed my will. That's a lot different than forcing the issue because you are worried about an outcome that hasn't been determined yet. Anything can happen if you are willing to put in the work and remain open to the possibility. Dreams are realized by effort, determination, passion and staying connected to that sense of who you are.

WHY ME? WHY NOT ME?

If you want to win, you have to pay the price—it's not that complicated. If somebody didn't want to hear that from me, fine. But go play somewhere else. Come on, man. You might be sick, but you can still play. Just the threat of you being out there is greater than sitting in street clothes. I remember when we were playing Detroit, and one of our guys was bent over after getting hit. I said,

"DON'T LET THEM SEE YOU IN PAIN."

YOU KNOW WHY?
BECAUSE THEY'RE GOING TO DO IT AGAIN, AND THAT'S GOING TO TAKE YOUR MIND OFF WHAT YOU NEED TO BE DOING.

Show that you can stand up to whatever they have to give. Let them know it's not affecting you, and they won't do it again. But every time you wimp out, bitch about it, or cry to the referee, all I'm going to say is, "Shut up. Let's play." You know what they're trying to do. Don't let it happen. Play right on through all that stuff.

That's when the Chicago Bulls started to get tough—when everyone else learned how to play through all the crap Detroit threw onto the floor. When Scottie Pippen would be talking trash or getting involved in a fight, I would step in and let him know I was standing there with him. They won't attack me because they know I'm not going to back down. And my game is definitely not going to change. You want to hit me every time I come into the lane? OK, then I'm going to the free throw line and knock down 85 percent. But I am coming back down that lane. There might not be other guys on my team coming back, but you can be damn sure I am.

FRED WHITFIELD *I have run a basketball camp in my hometown in North Carolina for more than 20 years. The first year of the camp coincided with Michael's rookie season. Out of the first 20 years, he had been there 18, and the only two he missed were summers when he was getting ready to play for the Washington Wizards.*

EVERY YEAR HE FOUND A WAY TO MAKE IT— THAT'S MICHAEL.

Every year we have what we call "The Greatest Pickup Game in the World," because there are always about 15 NBA players at the camp. Michael would always show up joking, having a good time. One year, Lance Blanks, who was a friend of ours, came to the camp, just like he had been, only this time he was playing for the Detroit Pistons. He was drafted by Detroit in the first round of the 1990 NBA draft, and that following season was the year Detroit was swept by the Bulls in the playoffs.

Now Lance had been coming to my camp for three or four years. He had played against Michael in these pickup games, and they had become friends. But in 1991, Isiah Thomas and all the Pistons guys walked off the court past the Bulls bench before the final game ended. Well, Lance didn't know what to do. He was a rookie on a championship team. He figured, "I better follow Isiah because I'm a rookie." So he walked right by Michael and didn't offer congratulations, nothing.

The camp was a couple weeks after the Bulls beat the Lakers for their first NBA championship. Michael is sitting in this high school locker room when Lance walks in the door. Michael curses Lance up one side and down the other. He said, "I thought we were friends. We've been coming to Fred's camp for years, having fun, and you're going to walk off the court without saying a word? I thought we were bigger than that. I'm getting ready right now to go out there and bust your ass right here in front of everybody. I'm going to embarrass you today."

And he did. He killed Lance. Michael went at Lance like they were playing Game 7 of the world championships. Michael had to have 45 points on the kid. It was intense. And for like 10 years, I didn't see Lance again. It's like he just fell off the map on me. When Michael, Rod Higgins and I went to the Wizards, we were at a pre-draft camp. Lance had just been hired by San Antonio as a scout. He came up and apologized to Michael. Lance had lived with it all that time. He hasn't been to my camp since that day.

Michael said, "No problem. We're way past that. I just want you to know, man, in this game people are going to win and people are going to lose, but if you have friendships in this thing, you have to have respect for your friends."

I had known Lance forever. We finally got through Detroit, swept them on their home floor. Lance walked off the floor as the clock wound down, just like the rest of them. We used to play together every summer. What happened? All of a sudden you don't like me, or you let yourself be influenced by those guys? I saw him later that summer, and took off on him.

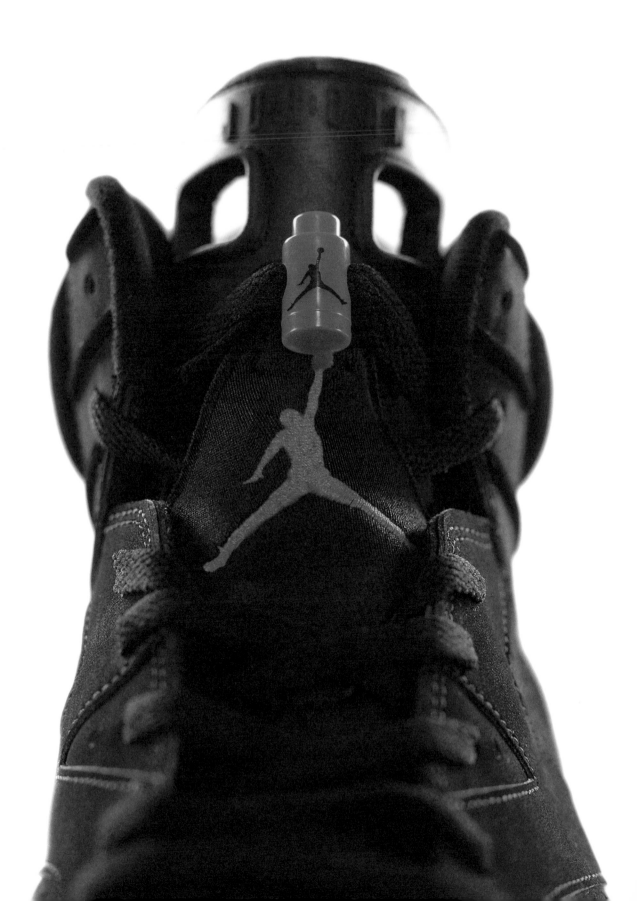

TINKER HATFIELD *Before we started working on the Jordan VI, Michael came up to me and said, "No more tips. When I buy my Italian shoes, I don't like a tip on the shoe. I like them real clean." I had clear orders to create a shoe with a clean toe, which made the VI maybe the first modern basketball shoe without a tip or extra reinforcement around the toe.*

Since he would still sometimes blow these shoes out in the course of a game, the clean toe became a starting point for the shoe. I stayed with the clear rubber, but we had some reports that the bottom was attracting dust for kids playing on courts that weren't clean. The dust would stick to the clear bottom and make it a little slippery. That never happened in an NBA game because the floors are spotless. So I put a little solid rubber in there, so kids who were playing on a floor that wasn't spotless would have enough traction.

I asked Michael if he ever had trouble getting into his shoes. He said yes, so we put a couple holes at the top of the tongue so he could put his finger in there. He suggested we put one in the back, too. We called that piece a spoiler. It was designed to be like the spoiler on the back of a sports car. Michael had a slant-nosed Porsche at the time, so the spoiler became something that you could put your fingers through and pop the shoe on real fast.

SPORTS CAR MEETS BASKETBALL SHOE WITH A SPOILER ON THE BACK.

That was the first shoe that had any sort of molded structure in the back. I remember Michael telling me to be sure to position it in such a way that it didn't hit his Achilles when he flexed his foot.

A leader has to be willing to sacrifice to help everyone else get to where a team needs to go. No one could take days off with the Bulls because I never took a day off. Horace Grant and I had a falling out because he wanted a day off here and there, and I would chastise him for it. I challenged Orlando Woolridge early in my career, and he wanted to fight me. I earned that responsibility. I wasn't making anything close to my value on the basketball court, but I never allowed that to affect the way I played.

MY GAME WAS NOT CHANGING, AND YOU NEVER HEARD ME COMPLAIN ABOUT WHAT I WAS BEING PAID.

Once I signed a contract, I moved on. So how could anyone else come to our team and gripe about how much money they were being paid? Pippen never complained about his contract until I was gone. No one complained, because I never complained about it.

ONCE I GAVE MY WORD, AND SIGNED ON THE DOTTED LINE, I STUCK WITH IT. THAT'S WHAT LEADERS DO.

They set a standard, and everyone has to live up to that standard if it's a good standard. It's the same in every great organization.

And it's exactly the same approach we have taken at Brand Jordan. It goes back to me, Tinker and Mark Smith. If we all agree to the standard, relative to what a particular shoe is about, and it's in line with what the company is about, who's going to try to change that? We've built the standards. We're leading, not following. We've earned the right to define the road ahead.

Whoever comes in has to live up to the same standard. They have to be as dedicated as I am. They have to put in the same effort. They have to have the same understanding of what our products are about. It's not about applying colors to something and selling it. It's about building a quality shoe with a style that is different and unique. If you don't have that same vision, then you're not going to be here, at least not as long as Tinker, Mark and I are still around. You have to rise to our level. We're not going to drop down to yours. I apply that standard to whatever I do.

——

MOM I remember when the Bulls starting winning championships, and the press started saying that Michael wasn't being paid enough money. I would tell him that his word was his bond. "You signed a contract, not knowing how your skills would develop, not knowing who was going to surround you. You agreed to that contract, and you have to honor that contract. If Mr. Reinsdorf decides the team had a wonderful year, and he wants to redo your contract, fine. But don't make it an issue because then you are not living up to your responsibility."

What is for you, nobody else can have. What is not meant for you, you cannot have. They will print whatever they will print, but a contract is an agreement. When you have a good heart, stay committed and focused on what is right and honest, everything will come to you. Michael earned every bit of it. I tell people, do you know about the ice packs on his knees, how he hobbled out of the Stadium some nights, barely able to make it home?

I remember that day in Utah. I'll never forget that day. I told him, "Don't play tonight. You are too sick." And what did he do? The best came out because you find that little bit of strength when you keep going inside, looking for it. That's determination and focus—the idea that he wasn't going to give up until he had given his last. That's life.

GIVE IT YOUR BEST, AND ALL THE OTHER THINGS WILL COME TO YOU.

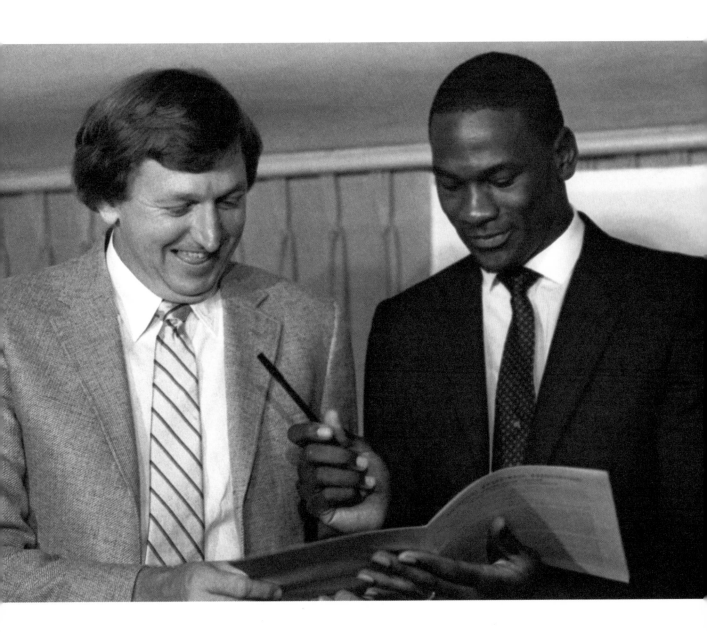

HOWARD "H" WHITE *Go back to any religion, and the core principle is that God is within us. If you take an orange, all you have is a sphere, a round piece of fruit. If you take the peel off, then you have something to eat, something that can nourish you. And inside that you have seeds that you can plant so you can eat forever. That's essentially who we are, but we rarely get to the seeds because we spend so much time focusing on the exterior.*

Rarely do people get to those seeds that can light up the world. MJ saw himself as far more than what others said about him. Now, this is the interesting part. He became able to see himself. The true art of meditation is being able to look out past all the words, actions and events, and back in at yourself. The responsibility is vast for those who can do that. Michael not only played up to the expectations of people, but he exceeded our expectations for him. To be great in athletics, your opponents have to have the idea that they have to play their very best. Everybody understood what Michael Jordan was bringing to the table. Again, it could have been a game, a shoe or anything else, but Michael was bringing everything he had all the time. When the other side knows it has to be prepared to give its very best at every moment, they often stumble. It's unnatural to play that way, particularly against someone who is simply expressing who he is in that moment. Michael didn't have to think about anything. The way he played was who he was.

It was self-expression in its purest form. So once Michael starts making things happen, the other guy figures he has to try harder. Michael was Michael. He never had to think about playing harder or lifting his game.

Go back to that playoff game in Chicago against Cleveland in 1989. The Bulls had a chance to close out the series at home, but Michael missed his free throws. Not just one. He couldn't make free throws that day, which is something that never happened.

Now the series goes back to Cleveland for a deciding Game 5. We're sitting in his room and Michael says, "Let's watch a movie." There was just a black screen as we waited for the movie to come on. He was fixed on this empty television. I finally had to say, "Hey, are you all right? Are you with us?" Was he watching the game on that black screen? Was he visualizing what was about to happen? That was the day he hit the shot over Craig Ehlo to win the series.

WERE ALL OF THESE THINGS SUPPOSED TO HAPPEN?

SOME THINGS ARE MEANT TO BE.
I TRULY BELIEVE THAT.

TINKER HATFIELD

I THINK HE'S JUST DEADLY, COOLLY EFFICIENT.

You kind of wonder at times if he doesn't have a little more perception than most of us. Not only does that give him more confidence, but it probably also increases the amount of times he's right. His technique on the floor when he played was perfect. His shot, his follow-through, the way the ball rolled off his fingers—he was a meticulous player. There are other players like that. But there are no other players who combined that meticulous approach with an ability to play like they had eyes in the back of their head. Michael made decisions that you just didn't have any idea where they came from. And that combination just doesn't exist.

Michael could be unconscious and at the same time see things that no one else could see. And it's the same off the court. You just have to sit back and marvel at it. That's just way different than anyone else. You can go down the list of all the great players in the world. There are some who are meticulous and perfect in the way they play their game, and there are others who are all over the place. But the very best player who ever played the game was the rare person who had the ability to do both, at all times.

__GEORGE KOEHLER__ You would think that with everything going on in Michael's life, particularly when he played, that somebody would be doing all the little things for him. No. When Michael would lay out his clothes before a trip, he would put everything together. There's the jacket, there's the shirt, there's the tie, there are the socks, the cuff links are already in the shirt, the shoes—it was one complete outfit, each one laid out on the floor. To give you an idea of how extreme he was, Michael would actually put everything on to make sure it was right. Then he would take it off, put it back on the hanger and pack. Who thinks like that?

——

I FOCUS ON THE LITTLE THINGS. LITTLE THINGS ADD UP TO BIG THINGS.

——

MICHAEL'S WHOLE BEING IS ABOUT LOYALTY AND WINNING.

HE REALLY FEELS LIKE YOU CAN'T RIDE THE FENCE.
YOU HAVE GOT TO BE LOYAL TO WHAT YOU
BELIEVE IN, AND THEN ALWAYS BELIEVE YOU'RE
GOING TO WIN. THAT'S PROBABLY WHAT I HAVE
LEARNED FROM HIM OVER ALL THESE YEARS.

I was really close to Ralph Sampson. Ralph had a big Puma contract coming out of the University of Virginia. He was Puma's man. When I would go up to Boston with Ralph, we'd go to the Puma warehouse. I would do the same thing when I'd go out to Nike with Michael. They'd say, "Whatever you want, pick it out and we'll ship it to you." I had my closet separated out, half Puma, half Nike. I had 25 or 30 pairs of Pumas, Clyde Frazier's in every color. Then I had all my Air Jordans, Nike stuff.

Michael comes to my apartment in Greensboro one time. We're getting ready to go out, and he says, "Man, it's kind of cold. Can I borrow one of your jackets?" I said, sure, go in my closet. He went in there and saw everything separated out. He's in there a little longer than necessary, and here he comes out of my room.

He's taken all my Puma stuff, brought it out into the living room and laid it on the floor. He goes into the kitchen, gets a butcher knife and literally cuts up everything. This was like his second or third year in the league. He literally took a butcher knife, and he's inside the suede shoes, ripping, cutting. When he's all done, he picks up every little scrap and walks it all down to the dumpster.

He says, "Hey dude, call Howard tomorrow and tell him to replace all of this. But don't ever let me see you in anything other than Nike. You can't ride the fence." From that day forward, I've never worn anything that wasn't Nike. That's the degree to which he believes.

IF YOU WALK INTO A ROOM WITH MICHAEL,
THE FIRST THING HE'S GOING TO DO IS LOOK AT
YOU FROM HEAD TO TOE. HE'S GOING TO LOOK
AT YOUR FEET.

If you're not dressed appropriately, he's going to let you know. Mike Phillips is a sax player with Hidden Beach Records. We signed him at Brand Jordan. Before he signed with us, Mike showed up one day with Reeboks on. He's in the limo with Michael, and Michael says, "Fred, you can't bring this guy around wearing those shoes." I mean, he gave Mike Phillips the blues. I said, "Mike, you have to throw those shoes away. We'll get you some new ones tomorrow."

THAT'S HOW MICHAEL THINKS.

TINKER HATFIELD *The inspiration for the design of the VII was tribalism, African art influenced by an Afropop Worldwide poster. I was walking down the street, thinking about the next shoe when I came by a little record store near my house. In the window was this Afropop poster. The guy in the drawing was playing a guitar shaped like Africa, and he looked like he was moving. It was tribal and exciting. I remembered a previous conversation with Michael when he talked about wanting the shoes to stay young and interesting, while remaining sophisticated. Now, young can go juvenile and become silly, or it can be vibrant and young in spirit, but still sophisticated in design.*

I went right inside the store. The owner didn't want to sell me the poster because he was advertising a radio show and the Afropop music. I told him I worked on design for Michael Jordan, and that I was really inspired by the poster in my quest to come up with some new ideas for the next Air Jordan shoe. Once he heard that, he said, "I'll let you have it for $15." After I designed the shoe and they heard a little bit about the story, I was asked to be on Afropop Worldwide's board of directors. They produce music and help young people in Africa find musical opportunities.

I CAN'T SAY ENOUGH ABOUT TINKER AND WHAT HE HAS MEANT TO THE JORDAN BRAND.

I love him to death, and his creative talent speaks for itself. We became a team. He understood exactly what I wanted in the shoes because he understood what was going on in my life at any given time. He had been a world-class athlete himself, so he knew it was about more than just looking at the numbers or responding to what the critics were saying.

I TRUST TINKER.

—

I THINK IN PREVIOUS YEARS, I WAS TRYING NOT TO BE INFLUENCED BY THINGS YOU MIGHT CONSIDER TO BE RACIAL OR CULTURAL ISSUES.

But the lines on the outsole design were directly inspired by Western African tribal patterns, and the vibrancy of the poster.

MOM *If you are not familiar with another environment, you can get boxed into what other people say or think about that environment. Michael wanted to be an Olympian for so many years. He always talked about wanting to play in the Olympics. When the time came in 1984, Bobby Knight was the coach.*

Michael said, "They say Bobby Knight curses and he's mean." I asked Michael who said that about Bobby Knight. "Well, that's what everybody says." What do you say? Michael said he didn't know the man. So how can you judge him? You are using another person's judgment. I always told Michael, "Get to know people yourself before you judge them."

Mr. Jordan and I drove to Bloomington to see Michael during those practices before the Olympics. I said, "Michael, tell me about Mr. Knight." Michael said, "Momma, he's fine. I like him. Some of his words aren't the best, but I like him."

—

The 1992 Barcelona Olympics was one the best times in my life. You're talking about the greatest players in the world, guys who'd had every story written about how great they were, all the things they could do and had done on the basketball court.

All I thought about was, "I have to see all this for myself. I want to see what these guys are all about." That was my motivation for going to the Olympic Games in 1992. I had won a gold medal in 1984; we were coming off back-to-back titles; and I was exhausted with all the business commitments. But I had to see these guys for myself. I'd played against them, but I wanted to see how they practiced. I wanted to see if Clyde Drexler, Karl Malone, David Robinson and the rest of them were competitive.

The best part of the whole thing turned out to be the practices. All we did was line up and play. We were all stars out there. We didn't need anybody to stand above everybody else. We'd been playing ball all our lives. We knew who we were. Chuck Daly? He'd just say, "Come on, let's get a hard hour or two in. Let's get loose." That's all he did. He didn't coach. He didn't call fouls. He just threw the ball out there. You had more people watching those practices, from Rod Thorn to David Stern, local media, foreign media.

The games were competitive as hell. It was up and down the court. We had 12 players, but John Stockton had broken his leg. Christian Laettner was on the team, but he was still in college, and no one would let him in the games. We played five-on-five. If Magic got off to a good start, or anyone else, the talking would start: "This is what's going to happen next year."

These were the teams: Me and Scottie Pippen, Chris Mullin, Larry Bird and Patrick Ewing. That was our five. They had Magic, Drexler, Malone, Charles Barkley and Robinson. We whipped their ass every day.

In Monte Carlo, we got into the most heated match of the entire time. Magic was telling us how great the Lakers were and how Showtime was the best basketball. Me and Pippen are listening on the way to practice, and we say, "OK, we're going to show you what these new kids are all about." Larry's back was hurting, so all he wanted was to get a good run in.

Me and Magic talked trash back and forth all day. I was guarding him, and I'm saying, "You don't have Kareem now. You got to do it all yourself." At the other end, he was guarding me, and if I blew by him, I'd be trash-talking: "You don't have Michael Cooper out here now. This isn't your old team." We beat them so bad that when the game was over, Magic said, "We ain't leaving. We got to keep playing."

Scottie and I looked at Bird, and we said, "We're ready to go." Magic said, "Why you ready to go?" And we said, "Because there isn't any competition here." Then Pip, who was the biggest instigator, started singing, "Sometimes I dream…"

Magic didn't speak to us for two days.

—

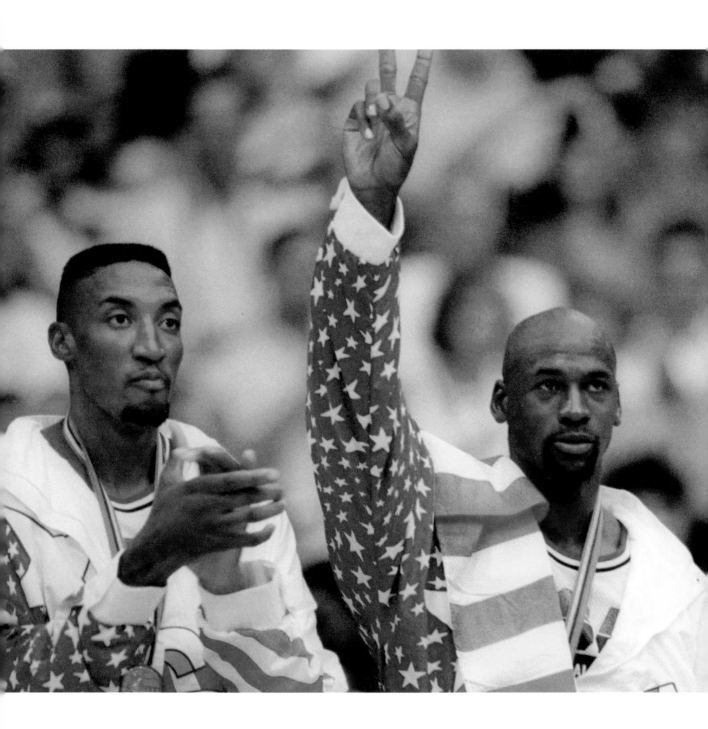

TINKER HATFIELD I've been around a whole lot of world-class athletes. A lot of people have a game face, or a certain way of getting prepared for a game. Michael is one of the very few who never really got uptight before the game. He never really had to go into what I call lockdown. A lot of athletes, they get edgy. They don't want to talk to anybody. Boxers or football players get themselves all worked up. He never did any of that.

The greatest example for me was on a trip to a game one night in Chicago. Howard is sitting in the front seat, I'm in the back, and Michael is driving to Chicago Stadium. It was Game 3 of the 1993 Eastern Conference Finals against the New York Knicks. Chicago had lost the first two games in New York, so the Bulls were coming back home for a real big game.

Michael wasn't the least bit worried about the possibility of going down 3-0. We get in the car, Howard's chitchatting a little bit, no big deal.

THEN MICHAEL DOES HIS FAMOUS DETOUR, WHERE HE GOES THROUGH THIS BAD NEIGHBORHOOD AND STOPS TO TALK TO FOUR KIDS ON THE STREET CORNER.

Then we drive to the Stadium. Michael has an abscess on his toe. One of the biggest games he's ever played in, and his toe is just killing him. He hated to have people look at his feet. This doctor is working on his toe, which was infected. The doctor lances the toe, and butterflies it together. The doctor's doing this, and Michael's talking the whole time.

While all this is going on, somebody walks in and gives him this big fat envelope. Inside the envelope is a stack of about 40 tickets for that night's game. He has the tickets, and he has a list of names. Then somebody brings in another 15 envelopes. He starts looking at the list of names, and takes the tickets. Looking at the seat and section numbers, he basically matches up the names with seats. Now it's down to less than two hours before the game. He's taking the time, after all the other stuff he had done, to actually concern himself with who was sitting where in the arena. And he probably had to buy all the tickets.

I'M JUST TOTALLY FLABBERGASTED BECAUSE I HAD NEVER SEEN A CELEBRITY OR AN ATHLETE BE SO NONCHALANT ABOUT WHAT WAS AHEAD, AND AT THE SAME TIME SO CONCERNED ABOUT OTHERS RIGHT BEFORE IT ALL STARTED.

I asked him about that later. "So how come you were the one picking out the seats? You could have had somebody else do that for you." He said, "I always want to pick out the seats because if somebody has a problem with them, I want them to know they can come to me, and I'll tell them why they got the seat they did." This is right before a game that, if they lose they probably don't go on to play for the third championship. And that was the title he really wanted. So that game was huge.

To me, that was a clear indication that this guy is so fine-tuned as an athlete, and he had such a strong sense of what he could do and how he could do it, that he didn't have to get freaked out before the game. He didn't have to go into lockdown, or sit in a dark room by himself. He's doing the tickets, talking to people, giving a high five to kid in a wheelchair by the court, laughing, talking.

TIPOFF. BOOM! HE'S A VICIOUS COMPETITOR.

He could just flip the switch. That's very, very rare. I don't think there has ever been anyone like that. It may exist somewhere, but I haven't seen it. I've been around sports my whole life, and I have never seen anything like that.

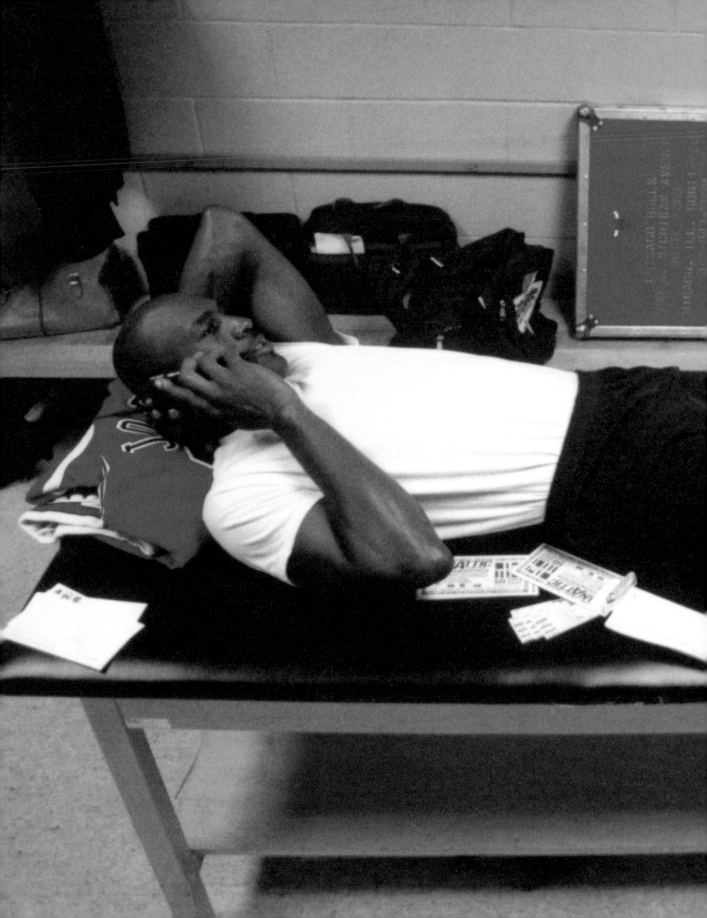

TINKER HATFIELD *I had been discussing the idea of eliminating the swoosh from Michael's shoes for a couple years. You can only imagine what kind of resistance I got from the marketing people at Nike Basketball. They basically told me I had to be kidding. It was a real struggle. I'm talking about knockdown-dragout arguments with people. I tried to eliminate the swoosh on the Jordan VI because I knew early on Michael was going to be strong enough in the marketplace to stand on his own.*

By the time we started on the Jordan VII, Michael didn't need the swoosh. That's why the Jumpman became so big on the sixth shoe. I was strategically making the Jumpman more important.

Although people thought I was wrong, I was able to make it happen. In the end, I most accurately pointed out that the decision lay between MJ and myself. We had been making those decisions all along, and that was my defense. MJ wants to do it; I want to do it. Who wants to step in and battle with both of us?

IT WAS A BIT LIKE POKER, WHERE PEOPLE STARTED TO SAY, "WELL, I'M OUT."

It was totally counterintuitive to brand marketing, but it made sense for what we were doing.

Right about that time, I had drawn up what I called the Jordan Manifesto. I had a diagram where I explained that for Nike to get a bigger share of the basketball shoe market, it would be better if Jordan peeled away to be its own entity. They were going to compete against one another a little bit, but in the aggregate Jordan probably would take market share away from somebody else. And it happened exactly that way, so I was vindicated.

I FELT LIKE THE JORDAN VIII INCORPORATED A LITTLE BIT OF A BAROQUE DESIGN PHILOSOPHY, MEANING ADORNED, COMPLEX AND WITH LOTS OF DETAIL. IT'S WHAT WAS HAPPENING IN HIS LIFE AT THE TIME, AS WELL.

The Bulls were about to win their third straight championship, and everything was getting bigger for Michael, on and off the court.

So the VIII was an explosion of design ideas, even to its detriment. It wasn't one of my favorite shoes in the end, but it did resonate at the time because it reflected Michael. And it reflected where I was, too.

There were people writing about the shoes in those days, but not so much from a business point of view. They weren't looking at the shoes and seeing that we had removed the swoosh and replaced it with the Jumpman. They were writing about what we were doing almost from a point of curiosity.

Now, we have pieces in the Smithsonian, and the shoes are written about by the high-design community of American art. But back then the gist of an article was more about how weird we were, and how odd it was what we were doing.

The VIII was a supreme, extreme example of a basketball shoe that I admit was a little bit over the top, but maybe for a good reason. We were just going to continue to keep veering off from where everyone else was going.

MOM

I KNOW PEOPLE SAY THAT WHEN THEY LOOK AT MICHAEL, THEY DON'T SEE HIM OF A PARTICULAR COLOR. THEY SEE HIM AS MICHAEL.

I always told him to see people as people, no matter what color they are, because when you cut their skin, their blood is the same color as yours. They are just like you. But I also told my children not to allow themselves to ever be intimidated by anyone.

I know people have said Michael is not black enough. I don't know what they mean when they say he's not black enough. He knows his culture. He knows where he came from. So what do you mean? Is it that you feel like he hasn't had enough poverty? That he wasn't raised in poverty? You have to address Mr. Jordan and myself for that, because we made sure he would know both sides.

HOWARD "H" WHITE I've been around Bill Russell. I've sat and listened to Bill. So it's real hard to say MJ had more drive than Bill Russell, because I don't know if that's true or not. Let's look at it from this perspective. People often say with Michael, "What does he stand for? He doesn't do anything for the black community. He doesn't do anything for the world."

If people could just take the ethic he applies to everything he approaches in life, then that's a whole heck of a lot more than telling somebody to do something.

THE ETHIC THAT HE COMES IN WITH, NO MATTER WHAT THE ENDEAVOR, IS WHAT THIS COUNTRY, WHAT THIS WORLD WAS BUILT ON.

The critics want something more, because they don't understand or appreciate what he's already given.

Michael once said, "I never want somebody to see me and wonder who they saw." Michael was aware somebody might be seeing him for the first time, or the only time. When they left, he wanted them to say, "Wow, that was Michael Jordan."

We were all sitting around one day before a game. He said, "Where are we going? We're going to work, and we all should look like we are." So you found that everybody around Michael was well dressed, and represented themselves in a way that followed Michael's example. Take that message. Integrate those values, his example into your life, and then let's see what you have.

LEADERS LEAD. A LOT OF PEOPLE TALK ABOUT LEADING, BUT IN THE END THAT'S ALL THEY'RE DOING, TALKING. I HAVE ALWAYS LED BY EXAMPLE. I DON'T BELIEVE IN TALKING ABOUT WHAT I PROVIDE TO OTHERS. THE LAST THING I NEED OR WANT IS TO DRAW ATTENTION TO MYSELF. THAT'S NOT WHO I AM.

MOM *Michael and his dad had it all planned. Michael told us to come to Phoenix, where the Bulls were playing in the 1993 Finals. He said, "If you want to see the last game, everybody must be there because this is it." He flew everybody in the family to Phoenix, and, boy, did they party that night the Bulls won the third championship.*

HE TOLD ALL OF US,
"THIS IS THE LAST GAME BECAUSE I'M PLAYING BASEBALL NEXT YEAR."

No one knew except those in the room. He and his dad had always talked about what it might have been like if Michael had played baseball instead of basketball, because they both loved baseball.

His daddy said, "You'll never know until you try." That started them talking about it. Michael held tight to his plan, even after the death of Mr. Jordan. One of Michael's dreams was to see if he could hit the ball as well as he did when he was younger. It was a challenge, and he loves challenges.

BUT IT WAS ALL ABOUT HOLDING ON TO A DREAM.

You could never say, "I can't" around our family. How do you know you can't? Go try it—that was a slogan for us. If you try, then you can't fail. You have failed if you don't try. You only have one life. Don't allow somebody else to live that life for you.

FRED WHITFIELD *They were playing Washington, and a bunch of Michael's close friends had come up from North Carolina. The team was staying in Annapolis, Maryland, at the Marriott. I'll never forget it.*

Michael said, "I'm going to walk away from the game. I'm going to let this game go, and play baseball." Fred Glover, one of our friends, said, "Man, you can't do that. We need our ride to keep rolling."

But Michael said he was going to let it go, and he was serious. When that whole thing went down, we were all in shock.

TINKER HATFIELD *Michael had gone to Asia for Nike around the time we started working on the Jordan IX. I remember being influenced by Japanese design. If you look at the back of the shoe, that's the rising sun. I thought MJ was really rising into his total dominance. Chicago was on its way to a third straight championship, and Michael had risen above any critics of his playing ability.*

WE ENDED UP WITH KIND OF A JAPANESE SIMPLICITY.

Michael didn't consider the leather on the front of the shoe a tip because I kept calling it a rand, and I think I kind of pulled one over on him. It actually looked pretty good because it wrapped all the way around the shoe and came up the back. It just looked fast. I liked the idea of the fingers on the side, which was a technical element to get more of a lateral support system.

ALL THE WORDS ON THE BOTTOM OF THE SHOE STOOD FOR QUALITIES OF MICHAEL.

The French word is liberté. We were trying to find words in multiple languages that defined Michael and his life, because by that point he had become a global superstar. I did a rough sketch, but Mark Smith came in and really designed the bottom in a beautiful, graphic way.

As a matter of fact, when I was asked which shoe should go on the statue in front of the United Center in Chicago, I chose the Jordan IX. They showed me a clay model of the pose, and I thought the neatest outsole we had that actually told a story was the IX. When Michael retired in 1993, he wanted to wear something familiar, so we turned the Jordan IX into his baseball shoe.

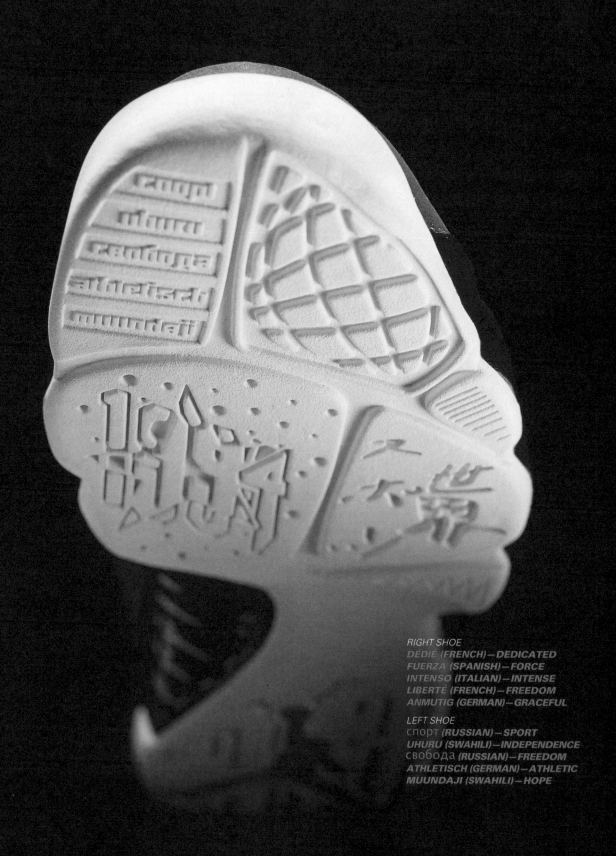

RIGHT SHOE
DÉDIÉ (FRENCH)—DEDICATED
FUERZA (SPANISH)—FORCE
INTENSO (ITALIAN)—INTENSE
LIBERTÉ (FRENCH)—FREEDOM
ANMUTIG (GERMAN)—GRACEFUL

LEFT SHOE
спорт (RUSSIAN)—SPORT
UHURU (SWAHILI)—INDEPENDENCE
свобода (RUSSIAN)—FREEDOM
ATHLETISCH (GERMAN)—ATHLETIC
MUUNDAJI (SWAHILI)—HOPE

Horace Grant and I never saw eye to eye because he was griping so much about what I was getting. There was a lot of jealousy on the Bulls by the end of that third championship season, and my relationship with Horace was tainting my relationship with Scottie. The harmony wasn't great. John Paxson and I were very close. But there were a lot of issues. And I was exhausted.

In my mind, I retired long before my father was killed. That had nothing to do with me going to play baseball. I had decided to retire earlier that season. My father and I had been talking about playing baseball for an entire year, all the way back to before the 1992 Olympics.

After we won the first two titles back-to-back, the only reason I came back was to win three in a row, which was something Larry and Magic never did. THAT WAS MY ONLY MOTIVATION.

My father's biggest passion was baseball. He was the one who got me started in baseball, and it was my first love, too.

I was just tired of being around the team. I had been there before any of them, so I felt a certain seniority. But everybody wanted to take credit. They'd talk about how I never won anything until they came around. I wanted to see if they could do it by themselves, so that had something to do with it, too. I was just fed up with all of it.

TINKER HATFIELD *It was a Sunday, and I was in my home studio working on the Jordan X, not knowing Michael wouldn't even play in that shoe. Phil Knight called me and said, "Pack your bags. When you come in tomorrow, we're flying to Chicago."*

He proceeded to tell me that Michael Jordan was going to announce his retirement from the NBA Tuesday morning. I was in the middle of designing the X, and Phil was treating it like the end of an era. He said what a great ride it had been. He was kind of sad and melancholy, but also a little bit celebratory, too.

I didn't have that reaction. I wasn't sad. I had the sense Michael was just taking a break. When Phil called initially, and I told him what I was doing, he said, "You might as well forget that." But after I got off the phone with Phil, I actually went back to work on the shoe.

WE HAD A BIG ISSUE WHEN I RETIRED IN 1993. NIKE DIDN'T THINK THE JORDAN PRODUCT WOULD SELL IF I WASN'T PLAYING BASKETBALL.

I have always believed—even to this day—the brand can withstand me being in the public eye or me being out of the public eye, because there is an established style in the minds of the consumer.

If we maintain the same innovative technology and creativity, the brand is going to be around for another 20 years. I do believe that. The foundation has been laid, the effort made to make the brand different from anything else. People know that from Day 1, I have had input into these shoes. If I died tomorrow, I think the shoe would sustain itself in the market. We have built a brand based on basic values, old-school values. Those never go out of style.

It was a tough fight because all the projections indicated that the brand would not survive. At the same time, I was in the process of signing a new contract. Nike said if the sales were X amount of dollars, then they would guarantee me X number of years on the new contract.

We rolled the dice. I said I'd fund my own guarantee if they would commit enough marketing dollars to allow the brand to expand. So I funded my own guarantee in the last contract I signed—for 30 years.

I put my money where my mouth was. We took the money Nike owed me and bought an annuity that pays a set amount every year for 30 years. Nike guaranteed X amount of dollars for marketing, and that provided us the opportunity to continue to grow the company, which is how we got to where we are now.

BUT I HAD TO COMMIT WHEN THEY DIDN'T BELIEVE.

AIR JORDAN 10
CONCEPT SKETCH
10.3.93

VERY SOFT GARMENT LEATHER

FULL GRAIN

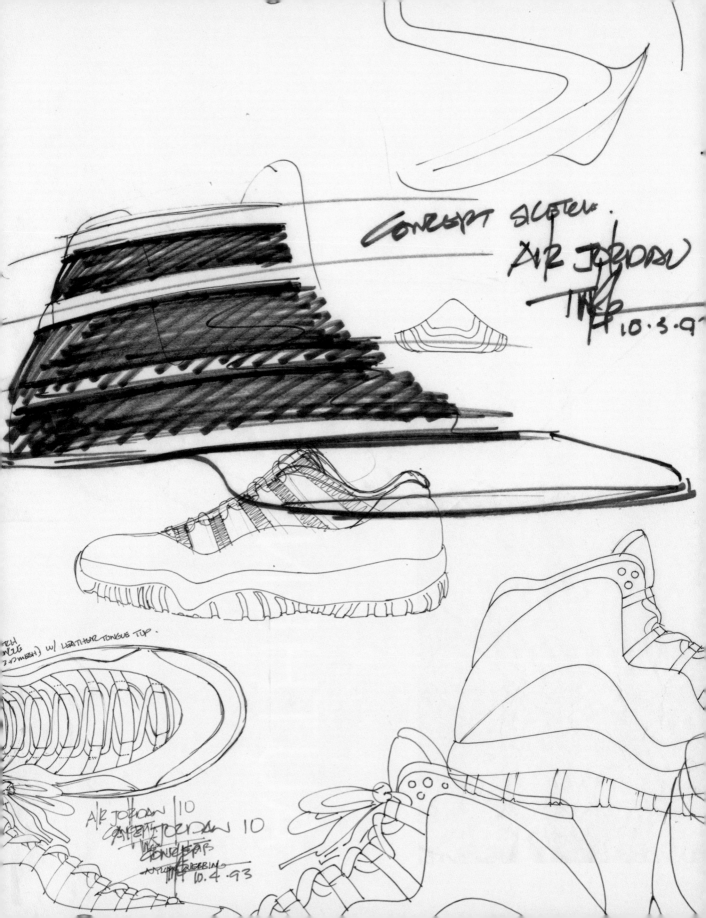

CONCEPT SKETCH.
AIR JORDAN
TINKER
10·3·93

AIR JORDAN 10
CONCEPT JORDAN 10
CONCEPTS
10.4.93

w/ LEATHER TONGUE TIP.

AUTHENTIC

THE TRUEST ATHLETES ARE GOING TO BE THE MIDDLE-OF-THE-ROAD PLAYERS BECAUSE THEY HAVEN'T BEEN GIVEN ANYTHING THAT THEY HAVEN'T EARNED.

Those guys are going to be more valuable to a team because they haven't been softened by the spoils. They are more likely to be leaders because of what they have been through. They know their skill level. They have a foundation. They are more confident in what they can do because they have had to focus on their limitations.

The player with all the accolades who hasn't done anything yet doesn't have that base. Look at the Detroit Pistons. Every guy on that team has been traded how many times?

Who is the leader of that team? Ben Wallace. What do you think he does? He practices hard, he plays hard, he doesn't miss games. He does all the little things. Everyone has to follow his example because if they don't, then they are the problem. No one is ever going to point at Ben Wallace, just like they never pointed at me. He's an All-Star, defensive player of the year, an extremely hard worker and a team player. It's hard to point at somebody who is going to be there every single day.

WE HAVE BECOME A SHORTCUT CULTURE.

To a certain degree, we define success on the basis of fictional attributes. If a guy has commercials, a lot of money, the girls, the car, then he's considered successful, whether his performance matches all those things or not.

SUCCESS TO ME HAS NOTHING TO DO WITH HOW MUCH MONEY YOU HAVE OR WHAT KIND OF CAR YOU DRIVE.

I ALWAYS WANTED TO KNOW WHERE I FIT IN WITH THE BEST.

AUTHENTICITY IS ABOUT BEING TRUE TO WHO YOU ARE, EVEN WHEN EVERYONE ELSE WANTS YOU TO BE SOMEONE ELSE.

That doesn't mean you don't have to play fair or conduct yourself in a respectful manner. But it's a lot harder to become the best you can be when you're focused on trying to be the best version of someone else. There's nothing authentic in that, and if it's not authentic, then it's not going to last.

TINKER HATFIELD First of all, I think he's from another planet. Everyone in the rest of his family is about 5-foot-7 or 5-foot-8, and Michael's 6-foot-6.

SO THERE WAS SOMETHING GOING ON IN THE COSMOS WHEN HE WAS COOKED UP. MAYBE IT'S NOT EXPLAINABLE.

When Michael's father passed away, Howard White, Phil Knight and I went to the funeral in this little tiny church in North Carolina. People were crying, and it was like a scene out of a movie. There was a fire-and-brimstone preacher, and he asked if anyone wanted to come up and say something about James. Michael's got two older brothers, an older sister, a younger sister, and they all are sitting there. All these famous coaches and other players are in the rows behind them. It was very emotional, almost intimidating.

Guess who walked up there and spoke? It was Michael. He hadn't planned on speaking, but the preacher had kind of made this gesture to the audience. You could see that Michael just gathered something up inside of him. He got up and gave a beautiful eulogy about his dad, totally unprepared. I'm certain he just felt the strength in him to go up and do it. The rest of the family was just too broken up. He had the strength to not only go up there and deliver a beautiful talk, but to hold it all together. His voice wavered a bit, but he got through it. I ended up doing that at my father's funeral, so I understand how difficult that was for Michael.

He said something when we were working on the Jordan XX that reminded me of that day. I was trying to get Michael to open up a little bit about who the mentors had been in his life. He talked about some of them, but he really focused on his dad. Then he said something that was very interesting. You would think that he learned from his parents how to be insightful and strong, with all that self-confidence. But none of his other siblings could do what Michael did that day in the church. They received the same lessons from the same parents, just like Michael.

He said, "You know, most of my family has not been able to get past my father being murdered. They still struggle with it to this very day. I looked at my dad, and I was able to think about him having had a good life, and also helping me have my good life. Then I was able to just put it all behind me and go on. I don't struggle with his death and the way it happened. It's time to go forward."

GEORGE KOEHLER

MICHAEL IS VERY SELF-CONTROLLED, VERY CENTERED. IT'S ALL FROM WITHIN. HAVE YOU EVER SEEN HIM LOSE HIS TEMPER? NEVER.

Even with his father's ordeal, Michael could step back and take a longer view. Who wouldn't want revenge? Who wouldn't want to see those guys die? Michael was very calm and collected. He said, "It doesn't bring my father back." Michael didn't go to the trial. I don't know if that's normal, but that's Michael.

HOWARD "H" WHITE When you get to the idea of the highest vision of one's self, that's spirituality in its fullest expression. There aren't many people who see themselves in that kind of light. It's hard for a lot of people to see through difficult moments. Not for Michael.

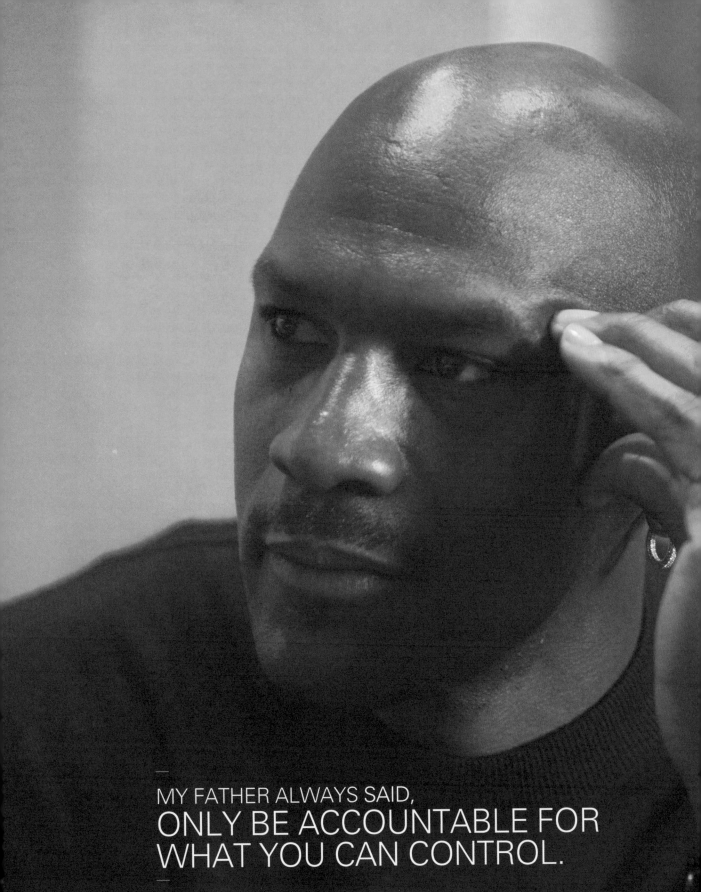

MY FATHER ALWAYS SAID,
ONLY BE ACCOUNTABLE FOR
WHAT YOU CAN CONTROL.

FRED WHITFIELD I can remember going down to the White Sox facility in Chicago with Michael. He was trying to improve the strength in his forearm.

THERE WERE 100 SHEETS OF NEWSPAPER IN A PILE, AND THEY HAD HIM GRABBING A SHEET, BALLING IT UP IN ONE HAND, THROWING IT IN THE TRASH. I WATCHED HIM DO THAT FOR HOURS.

GEORGE KOEHLER What Michael did to get himself ready to play baseball was grueling. He would get up every morning and go to the complex in Sarasota where the White Sox had spring training. It was early, way ahead of the other players.

The hitting instructor was Walt Hriniak. Michael would go into the cage and take what baseball players called flips. Walt would flip the ball, and Michael would swing the bat, knocking the ball into the cage. He would do that for an hour to 90 minutes. Then the team would show up, and Michael would go through the regular practice, which ran about three hours. Then he would talk to the media for a few minutes before going back out for another half-hour to an hour, taking more flips.

If you haven't swung a baseball bat in a while and decided to pick one up and swing it for 15 minutes, your hands would have blisters. His hands were so raw from taking flips that the calluses would rip open every day.

When he came off the field, I don't know how he could have held anything, much less a bat. The trainers would put a clear, rubberized patch over the inside of his hands. Then they would wrap his hands in gauze and tape.

HE LOOKED LIKE A PRIZEFIGHTER.

The next morning, Michael was back in the cage, swinging a baseball bat for hours. And he never missed a day. Not only did he not miss a day, but he never said a word about his hands. The trainers knew because they were the ones patching them up every day, but Michael never said a thing.

WHEN YOU'RE MICHAEL JORDAN, THAT'S HOW YOU GET READY. ONCE THE ON BUTTON IS PUSHED, THERE ISN'T AN OFF BUTTON.

I KIND OF LOST CONNECTION WITH THE BRAND THE YEAR I PLAYED BASEBALL, BECAUSE WE CAME OUT WITH A SHOE I DIDN'T APPROVE. I HAD SOME DIALOGUE WITH TINKER IN THE EARLY STAGES OF THE X DESIGN PROCESS, AND HE THOUGHT WE WERE IN AGREEMENT. I ALWAYS LIKED MY SHOES CLEAN-TOED. WHEN I SAW THE FINAL VERSION OF THE X, IT ALREADY WAS IN THE MARKETPLACE, AND IT WASN'T CONSISTENT WITH THE WAY I THOUGHT THE SHOE SHOULD LOOK.

THERE WAS A STRAP OF LEATHER GOING ACROSS THE TOP OF THE TOE. THERE WERE A BUNCH OF THEM IN THE MARKET AT THE TIME, BUT WE CAME BACK OUT WITH THE CLEAN-TOED VERSION. I NEVER WORE THAT SHOE. TINKER THOUGHT HE KNEW WHAT I WANTED, AND EVERYONE WAS WORRIED BECAUSE THEY THOUGHT WE HAD CONFUSED THE CONSUMER BY COMING OUT WITH TWO VERSIONS. BUT I WANTED THE SHOE TO BE RIGHT.

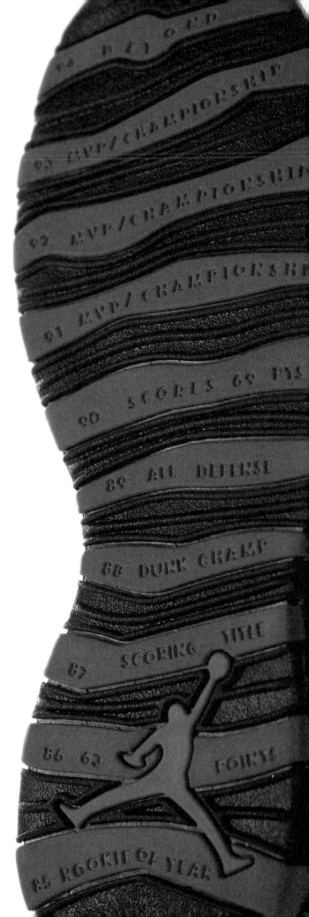

TINKER HATFIELD The Jordan X turned out to be fairly commemorative because on each stripe was one of Michael's accomplishments. That was a time when many people at Nike didn't want to do any more Jordan shoes. The thought was,

"HE'S RETIRED. LET'S MOVE ON."

Even Phil was lamenting the end of an era.

THAT WAS THE OVERWHELMING AND PREVAILING ATTITUDE AT NIKE IN 1994:
IT'S OVER. IT'S DONE.

I felt like I was at a point where I had enough clout that I could keep the development of the Jordan XI going single-handedly. I chose to keep a certain percentage of my time dedicated to keeping the brand alive.

I remember talking to Howard White over and over again. I kept asking him if MJ was talking about coming back, and Howard would always say, "He's done. He's out, Tinker." Having said that, Howard did say, "I think it's OK that you keep this thing going, even if he doesn't play again." I think Howard had a feeling similar to mine, that maybe—whether Michael ever played basketball again—the brand could stay alive. I know I totally believed that.

So we fast-forward a few months. The X is put to bed. Begrudgingly, there is some activity on the part of our marketing and sales force. Europe didn't order any of the Jordan X. Zero. To a lot of people it was like, well, he's done, so we're done. Nike's a fast-moving, ambitious, forward-thinking kind of place, so the sense was that it was time to figure out something else to do. But I was thinking about Michael coming back to basketball.

I THOUGHT WE SHOULD PULL OUT ALL THE STOPS AND MAKE A SHOE OUT OF MATERIALS THAT HAD NEVER BEEN USED IN A BASKETBALL SHOE.

I was looking at nylons you would find on high-end backpacks. I thought about how this shoe could be designed kind of like a convertible car, where you had this shiny body. I even wrote it down: "It's got rubber on the bottom, then it has a cloth top." I sketched up a car to explain the thought process, and why the shoe started looking the way it was looking.

Sometimes when I had people going my way, I would hit them with one last thing. The Denver International Airport had just been built, and it was shiny with a cloth top. So I was even trying to use architecture as a way to tell a bit of a design story.

You might ask the same thing about the yellow lawn mower on the inspiration board [pages 144-145]. I thought it was interesting that someone was thinking that even a very pedestrian, everyday utilitarian piece of equipment could be designed to be cool. I remember feeling compelled to defend the use of patent leather, nylon cordura, clear outsoles and carbon fiber plates.

That's a lot for people to absorb, but I was saying, "Look, there are designers out there designing lawn mowers to look like sports cars. It's OK. This is the kind of direction I want to take."

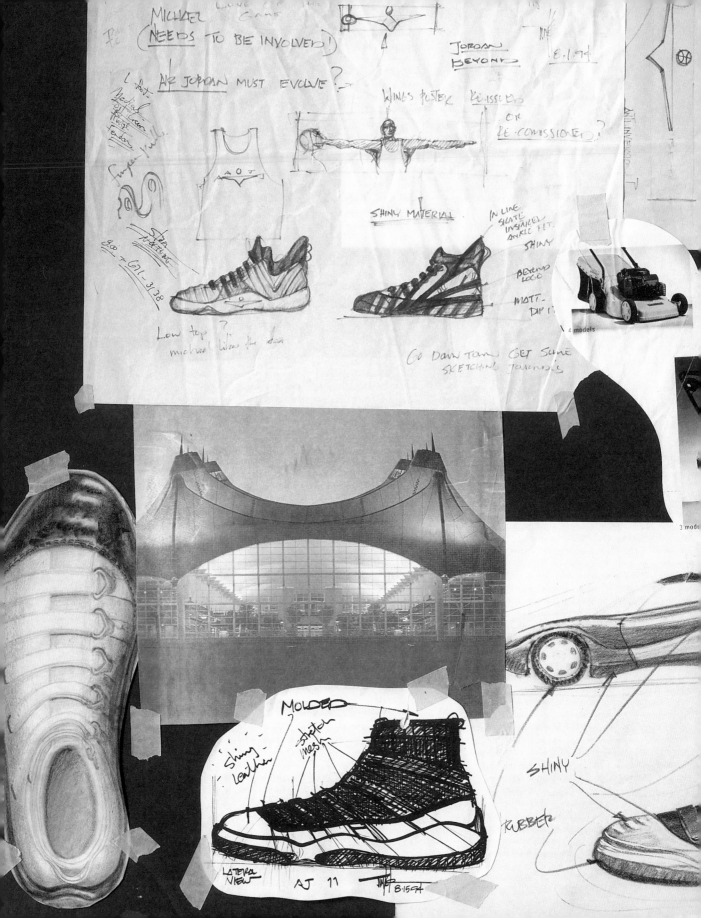

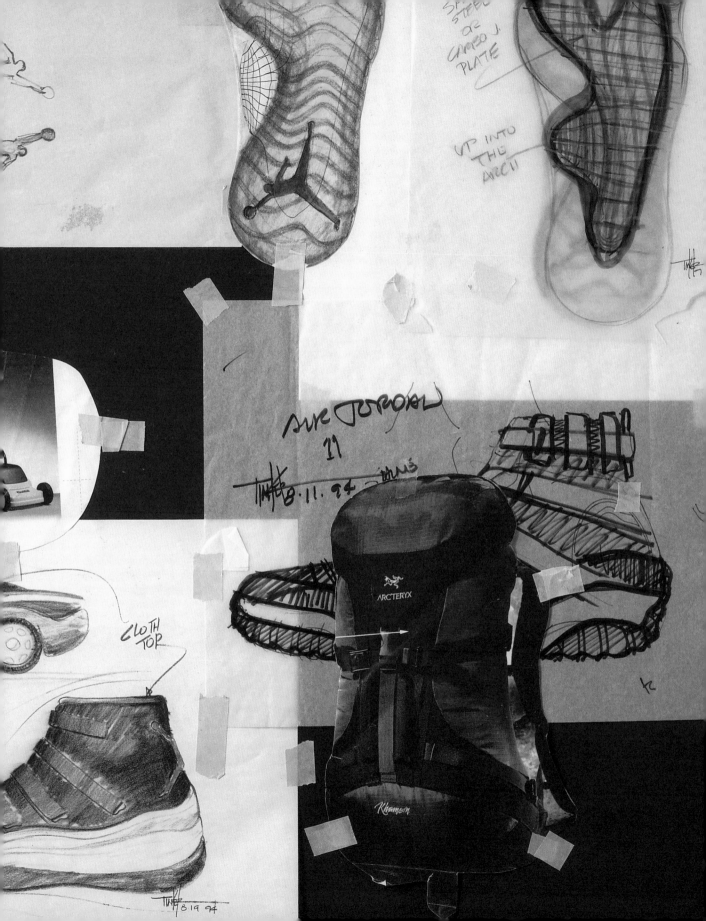

GEORGE KOEHLER *Baseball was a bonding experience for Michael. It was a team. It was like a family that did everything together. Not to knock the NBA, but there are a lot of egos involved on an NBA team, because there can be significant differences in what guys make.*

NBA guys get into the locker room after a game, shower, talk to the media, and most of them leave separately. In baseball, when the game was over, the players would sit in the clubhouse for a couple hours. They'd drink a couple beers, play dominos, spades or gin.

THEY'D MAKE A PEANUT BUTTER AND JELLY SANDWICH.

When somebody left, the others would ask where he was going. These guys were 18- to 25-year-olds, and they were just trying to make it.

Michael had more money in his pocket than some of those guys made in a year. I saw guys get up in the morning and walk a mile to Denny's because they had a $1.99 breakfast. And we weren't staying at the Ritz-Carlton, so it wasn't like there was room service in those hotels.

FRED WHITFIELD *Everyone said Michael bought the team a bus, but he worked out a deal where he bought it and sold it back to the team when he was finished playing. They used to travel around in this little white school bus that would break down all the time. He got a better bus, but it wasn't like the John Madden cruiser.*

These guys would play games at 7 o'clock at night because the days were hot as hell. Then at 10:30, when the game was over, you would shower and drag your own bag to the bus. Then sometimes there was an 11-hour drive all night. It was pretty much like Bull Durham.

I DON'T THINK I WOULD HAVE COME BACK IF THERE HADN'T BEEN THE BASEBALL STRIKE.
THEY STARTED THROWING ME INTO THAT DISPUTE, SOMETHING I HAD NOTHING TO DO WITH.
I WAS HAVING FUN DOWN THERE PLAYING BASEBALL. AND IT WAS AN OPPORTUNITY TO
PROVE SOMETHING. I WAS GETTING BETTER ALL THE TIME. ALL I NEEDED TO GET THAT URGE
BACK WAS TO HANG AROUND THE BASKETBALL COURT FOR A WHILE.

—

I REMEMBER GOING TO BIRMINGHAM AND BEING BORED TO DEATH.
MICHAEL LOVED IT. HE TRULY LOVED IT.
BUT IT WAS A LITTLE BIZARRE.

Those guys had old cars parked in the players' lot, and Michael was parking his Porsche out past the outfield.
He's got his 911 Porsche, while these guys are driving old Volkswagens.

The team came to North Carolina on one trip, and we all went to watch Michael play. The Barons were
staying at the Days Inn.

ONE YEAR EARLIER, MICHAEL WAS STAYING AT THE RITZ-CARLTON
IN MARINA DEL RAY, CALIFORNIA, AND NOW HE'S AT THE DAYS INN
IN RALEIGH, NORTH CAROLINA.

He was cool with it, though. But it was really weird. Unbelievable.

It was good for him to get away, but I think he still had a burning desire to get back to basketball. He had
a basketball at the house in Birmingham. And he'd go play ball with the guys on the team. They'd go to local
parks in Birmingham and play pickup games. It was almost like going back to high school. Michael was just
a regular guy. He could go out to dinner without being mobbed. Less than two years earlier, there had
been a banner of Michael hanging off a 10-story building in Barcelona, with presidential-like motorcades
taking the Dream Team to and from practice. It's hard to explain how different it all was.

GEORGE KOEHLER *Everywhere Michael went, everyone would ask for autographs. We would get to the clubhouse, and there would be six baseballs in a tube sock with the top tied closed. They would be at Michael's locker. The umpires would ask for autographs. If Michael didn't sign a thousand balls, it was a bad day.*

Some teams would put up extra bleachers or seats when Michael came to town. He loved it. He didn't care about the expectations. What did he hit, .202? There's probably a half dozen guys making a million dollars in the big leagues hitting .202. And that was just one year for Michael. Those other guys had been playing their whole life. Michael hadn't played since he was 15 or 16 years old.

That first month he had a 13-game hitting streak, and he was hitting over .300. Could Michael have been functional on a big league team? Maybe. Could he have made $6 million a year? No, that's absurd. But for picking up a baseball bat for the first time in 14 or 15 years and playing one year,

I THINK IT WAS PRETTY PHENOMENAL.

Just look at what he led the team in that season. He led that team in RBIs with the bases loaded, and RBIs with two outs and runners in scoring position. He might have batted .202, but he found a way to hit when it mattered most.

If he had played the second year and improved from .202 to whatever, who knows what might have happened? Michael being Michael, if he had been able to get to .250, then he would have thought he could get to .270 and eventually .300. Could he have done it? I don't know, but I wouldn't have put it past him.

—

I'VE NEVER BEEN WORRIED ABOUT ANYONE'S PERCEPTION ONE WAY OR ANOTHER. I'VE NEVER ALLOWED ANYONE'S OPINION TO DEFINE ME. I'M COMFORTABLE WITH WHO I AM. I TRUST MYSELF.

—

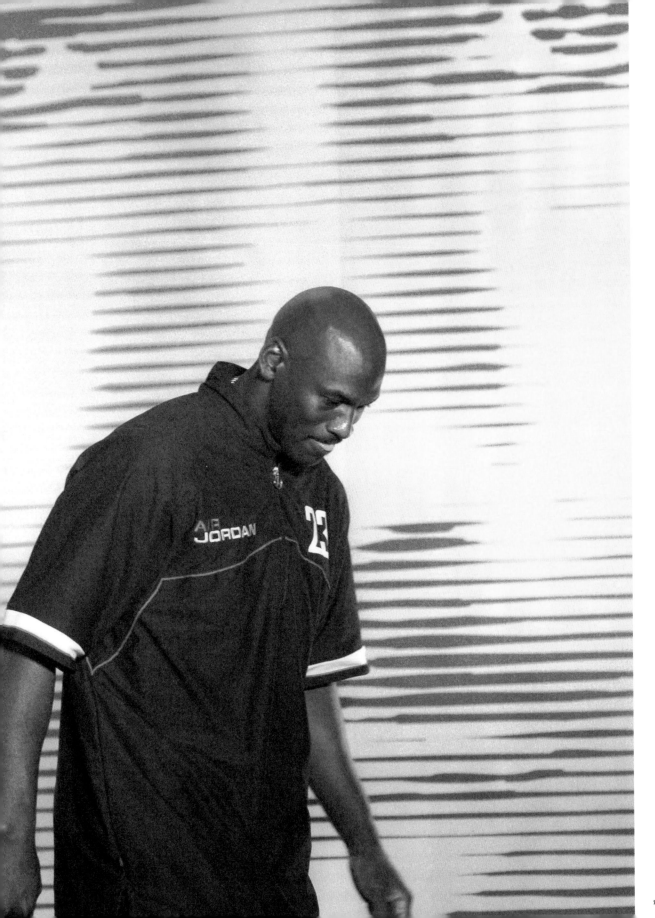

TINKER HATFIELD *We would take high-speed footage of players, then slow it way down. It was really the first time I looked at the degree to which Michael's shoe would deform as he moved on the court.*

Michael had become this prototypical new player. He was like Dr. J, in that he was as quick as a little guy, but he also was good-sized.

WITH ALL THAT MASS MOVING AROUND, AND MICHAEL BEING ABLE TO CHANGE DIRECTION SO QUICKLY, HE WOULD TORTURE HIS SHOES. HIS FEET WERE INCREDIBLY MESSED UP, JUST DESTROYED BECAUSE OF THE FORCE.

When we slowed down the footage of him playing, you could see his shoes twisting and turning— they would elongate and stretch or roll over. I remember going back to my own high school days, playing football. I would get new shoes fairly often, and I remember feeling faster because I had new shoes. I remember how quick it made me feel.

I thought, why don't we take the kind of torsional rigidity you get from a football shoe and put it into a basketball shoe in the form of a stiffer plate on the bottom. Why don't we transfer that rigidity, and see if it doesn't make the player a little quicker by retarding or even stopping the rotational deformity. The idea was to put a carbon fiber plate on the shoe, which no one had done before.

If we had a carbon fiber plate sitting just inside the outsole, why not let it peek through in a few spots so you can see the technology. It would look cool, as well as enhance performance.

The only place in footwear that carbon fiber had been used before the Jordan XI was in speed Rollerblading. They were making bucket-like shapes on the uppers, which were bolted to the in-line skate. The whole idea of stiffening up a shoe torsionally started there.

BEFORE THE XI, MICHAEL'S SHOES COULDN'T LAST MORE THAN A SINGLE GAME.

They were toast. Technically, we were on to something that had never been done before. But inside Nike, I was being asked why I was spending so much time on the development of a shoe that no one knew for sure Michael would ever wear.

I will give [Nike co-president] Mark Parker credit. I used to say that if you really wanted to do well in the Nike environment, you needed to do good work, but you also needed a rabbi. You needed somebody to help counsel you, but also someone who would be your protector. Mark Parker was that guy for me. He would kind of call off the dogs and give me room to work, even if he didn't necessarily agree with the idea.

FRED WHITFIELD *I was working for David Falk at a NCAA regional basketball game. We were trying to sign Jerry Stackhouse. Falk calls me and says, "Fred, get yourself to Indianapolis." I'm thinking, the game is Sunday, and I need to see Stackhouse. He said, "Quit asking questions." So I jump on a plane, and they tell me MJ's coming back.*

I WAS SHOCKED.

TINKER HATFIELD *I had jumped on the design early because I knew all the new technology was going to take too long on normal timelines. We had a couple pairs of the XIs to wear-test just before the playoffs. Michael had seen some rough samples, and now we had a playable version. I put them in front of him, and Michael got the biggest grin on his face.*

IT WAS LIKE THE JORDAN X HAD NO LONGER BECOME A FACTOR IN HIS LIFE.

He said, "I'm going to wear these in the playoffs." I said, "No, Michael, we're not selling these now. We're not selling them until November." He didn't care. We were able to make enough of them to get Michael through the playoffs. What was I going to do, wrestle him for them?

Ahmad Rashad was around Michael's house a lot in those days, and he's a smart guy. I had known Ahmad from the University of Oregon, where we were both athletes. But he went off the deep end over the shoe. That very first playoff game, Ahmad is courtside on-camera, with players warming up in the background. The arena is filling up. Ahmad finished with his opening comments, reached down and pulled up the shoe.

He said, "Michael is feeling great, but more importantly he's got these new shoes with patent leather." No one at Nike had any idea. I'm watching on television, and my jaw just dropped.

So we went back and filmed him again, and compared that high-speed footage with the footage of the previous shoes.

WE COULD SHOW THAT THE XI ACTUALLY MADE MICHAEL QUICKER.

It actually worked. The patent leather was a robust material that didn't stretch very much, and it was lightweight. The carbon fiber plate kept the shoe from contorting when he stopped. That shoe became one of the all-time favorites.

IT WAS ALL ABOUT HAVING FAITH. MICHAEL HAD FAITH IN ME, AND I HAD THIS WEIRD FAITH THAT HE WOULD COME BACK.

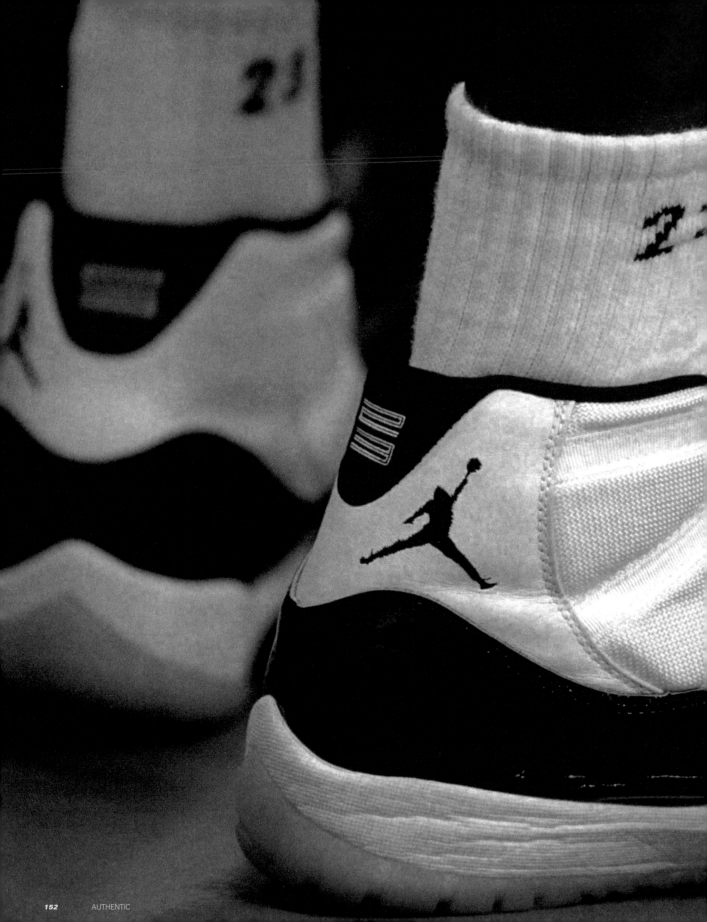

THE XI REPRESENTED ANOTHER NEW BEGINNING.

We were coming off a bad year where I had left baseball and we flopped in the playoffs. They said I was too old.

The same focus Tinker took into designing that shoe, I took into the summer and then right into the next season. Physically, I had a baseball body, and I had to spend the summer transforming my body back into a basketball body. In baseball, you work from your fingers to your shoulders. In basketball, it's chest, shoulders and legs, without a lot of wrist, fingers or forearms.

My forearms were so different by the time I came back to basketball that I had no control over some of my shots.

MY RHYTHM WAS TOTALLY OFF.

One night I could score 55, the next night I might score 20, and my shooting percentage was horrendous. The night I scored 55 against New York in Madison Square Garden, I was 21-for-37. The next three games I was a combined 26-for-67.

At the end of the season, I realized I had to retrain my body to get those muscles to respond. The day after we lost to Orlando, I was in the gym.

I HAD DOUBTS.
WHAT HAD I LOST?

What added fuel was the media saying I was a step slower, that the game had passed me by. That's all I needed. I played every day, and it was brutal. I treated everybody like the media. I got into a couple fights. I even fought with Steve Kerr in practice that year.

—

97 ⊗ 38

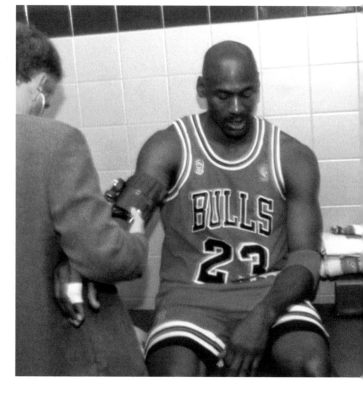

WHEN I CAME BACK, I DIDN'T HAVE TO TELL ANYONE ANYTHING. I SHOWED THEM.

I let my actions speak for me. I didn't have to tell Steve Kerr what his role was on those Bulls teams. I didn't have to tell Scottie or Dennis what I expected of them. They could see what I expected of myself went beyond the normal expectation.

My expectation was excellence each and every time I stepped on the court. Whether it was practice or a game, I was there to win. I didn't have any other agenda, and they knew that.

GEORGE KOEHLER *To this day, I don't think anyone appreciates how seriously ill Michael was in Game 5 of the 1997 Finals against Utah. In those days, Michael never really left his room. So we'd all be in there close by, to pass the time. We all ordered room service, and Michael didn't order anything. Then at the last minute, he ordered a pizza from a local joint. If I'm not mistaken it was a pepperoni pizza. Nobody ate the pizza except Michael.*

At two or three o'clock in the morning, Michael wakes up with an upset stomach. So he calls Chip Schaeffer, the trainer, who gives Michael something to settle his stomach. After the antacids, they gave him sleeping pills. Nothing works. He felt like throwing up, but he couldn't throw up. And he's getting hot and cold flashes.

All of this could have been attributed to the flu, or whatever. Now it's early in the morning, time to go to practice. So now they give him a laxative. He's too weak to go to practice, so he skips the shoot-around.

Michael tries to sleep, but he can't sleep. We get on the bus to go to the game at 3 P.M. and he's just a rag doll. He has no energy. He still hadn't thrown up. And he still hasn't slept.

NOW HE'S GOT ANTACIDS, SLEEPING PILLS AND LAXATIVES IN HIS SYSTEM.

At 5 o'clock, an hour before the game, he can't stay awake. So he pumps himself full of coffee. He goes out and plays, and we all know what happened. He plays 44 minutes, scores 38 points, brings Chicago back from 16 points down, hits a key three-pointer to put them ahead, and the Bulls win.

But at halftime, he's just drained.

IF YOU HAD SEEN HIM, YOU WOULD HAVE THOUGHT THERE WAS NO WAY THIS GUY COULD WALK BACK TO THE COURT, MUCH LESS PLAY.

Michael always drank Gatorade to fill himself back up with fluids. So one of the locker room kids went to get some Gatorade. Two cans come back, but it's not Gatorade. It's Gatorload, the stuff you are supposed to drink after you are done playing. Michael didn't even realize what he was drinking.

He hasn't slept in more than 36 hours, he's got pepperoni pizza, all the medicines, sleeping pills, who knows how many cups of coffee, Gatorload in his body—anybody else would have been in the hospital. And Michael should have been in a hospital. Nobody else would have been out there playing, much less been able to make a pressure shot and walk off the court.

Michael was so dehydrated after the game that he could hardly move. He looked like he was dead. He was barely conscious. I had seen the whole show to that point, and I am still amazed by what he did with what he had to deal with. That's just who he is, and it's hard for people to understand the depth of his will.

HIS WHOLE LIFE IS A COMPETITION—EVERY ASPECT OF HIS LIFE. AND HE'S GOING TO WIN. IT'S JUST THAT SIMPLE.

TINKER HATFIELD Michael has a feel for fashion, and I was quite intrigued by that. People don't expect athletes or jocks to be designers. I certainly wasn't on the level of Michael Jordan, but I could understand this meshing of two sides that don't normally go together. Over time, as he got more and more comfortable with me, our conversations become shorter, not longer, because we were on the same wavelength.

MAYBE ONE OF THE REASONS THINGS HAVE WORKED OUT AS WELL AS THEY HAVE IS THAT WE EACH HAVE INTUITION TO GO ALONG WITH SOME SKILLS.

I think we were able to work from that foundation. After a while, we still met often, but we no longer needed to talk about design direction for hours and hours. We could have a little argument about one direction or another, and often he would say, "I don't completely agree, but I trust you. Go ahead." That was important for the relationship because Michael doesn't trust a whole lot of people, even to this day. Somehow or another, we were making some kind of connection.

ROD HIGGINS When he first came into the league—he'll probably curse me for this—he used to wear Wrangler blue jeans. Can you imagine the Michael of today wearing Wrangler blue jeans? And he'd have penny loafers, or something like that. That's where he's evolved from, country boy to city businessman.

TINKER HATFIELD

MICHAEL HAD PREDICTED THAT PEOPLE WOULD START WEARING XIs WITH SUITS AND TUXEDOS, AND THAT'S EXACTLY WHAT HAPPENED.

We had talked about how being classy was part of our design philosophy. There were a couple of shoes that were a little wild, but the idea was to be unique and innovative, while maintaining a certain kind of restrained class. Even if the shoes weren't normal looking, they still had to have a classic feel.

Strategically at the time, Nike Basketball was going in one direction with foam posit, Shox, big air bags in the shoes, and Charles Barkley was being portrayed as a caricature. With Jordan, we wanted to be leading in a more sophisticated way. We didn't use Shox, we didn't use visible air, we didn't throw big straps on the shoes with lots of bells and whistles. We kept them high tech and high performance, but with sophistication.

WHEN IT CAME TIME TO DO THE XII, I HAD TAKEN A DRAWING OF A WOMAN'S FASHION SHOE AND TURNED IT INTO A BASKETBALL SHOE WITH A HEEL AND TOE.

That's how the XII got started. That shoe had an even more improved carbon fiber shank, so it had really good lateral stability. We didn't use patent leather, but we had a kind of lizard skin look to the leather that made the leather stronger. That shoe became a real asymmetrical medial-lateral story, looking like it was a high heel shoe from the fashion world. It was clearly aggressive, yet still sophisticated. That was the first shoe in the whole series that was purposely asymmetrical. We wove the carbon a little different to make it interesting.

I have to give Michael some serious design credit. We wanted to start using his number, 23, so we put it on some prior shoes. Then he said, let's change that up and put the number on there in a different way. It was his idea to spell out the number two on the tongue.

THE FACT THE INSPIRATION FOR THE SHOE WAS REALLY VERY FEMININE NEVER BOTHERED MICHAEL, BECAUSE HE'S SO FIXATED ON STYLE.

He doesn't care where it comes from. Style is style. If it comes from the women's side, that's fine. In fact, he has worn small narrow wristbands on his watch that look feminine. If he wants that thinner, lighter look, he doesn't care that somebody might think it looks like a girl's watch.

He's unfazed by labels like that. Michael's brand of leadership has always been to be cautious with his words, but bold with his non-verbal statements. That's the way he played, too.

FRED WHITFIELD *When he started wearing the baggy shorts, everybody wanted to wear baggy shorts. When he started to wear short socks, everybody wanted to wear short socks. But it was his style. No creases in his dress pants? Michael noticed that women's dress slacks didn't have creases. So when he started getting his suits done, he made sure they didn't have creases, because to Michael they just flowed better.*

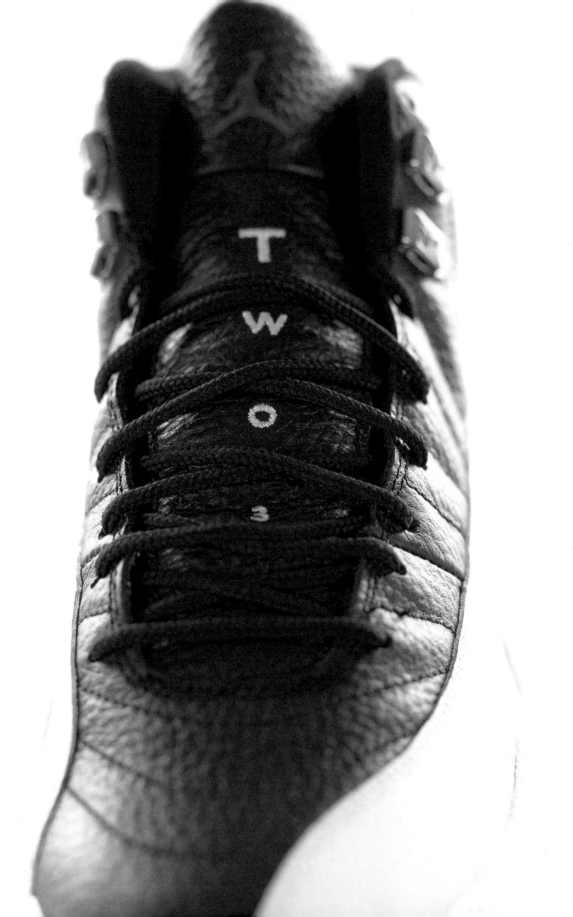

I will never do anything that isn't authentic or representative of me. So there was no way I was going to agree to any ads that had any relationship to snakes, which is what they wanted me to do for the Jordan XIX. I'm scared of snakes. I can't even watch them on television. If anybody drops a snake near me, somebody's going to get hurt.

The same thing happened when I showed up to do the commercial about the virtues of failure. The idea of not being afraid to make mistakes, or using negative outcomes to create positive ones was great. But the attire they picked out for me to wear was outrageous. They wanted me to come in wearing a hood with a darkness about me. They wanted this intimidating look: big black boots, jeans, and the hood pulled over my head.

First of all, I would never go to a game dressed that way. If you are trying to show me going to a game, then you need to show me wearing what I would wear to a game. It was a big deal, and no one wanted to give in. I ended up wearing exactly what I wore to the filming, because there was no way I would put on the wardrobe they had selected.

THE WHOLE THING BOTHERED ME.

I felt like the marketing people were trying to misrepresent who I was, or trying to mold me into something else. There is no way I am going to allow anybody to do that. If I am in a commercial, then I am going to be portrayed as the person I am, and certainly not someone created in a marketing meeting to appeal to the latest fad. That's not me. That's not Brand Jordan.

Don't try to change me to appeal to these new kids coming in wearing sweats to games with all their chains, their jeans, their hoods. No. The arena for me has always been a place of business.

I was taught to conduct myself in that manner from Day 1. At North Carolina, we had to wear suits, jackets, ties to the games. And I believed in that approach. No one ever saw me going to a game in jeans or sweats.

MY FATHER ALWAYS SAID, "THE FIRST IMPRESSION YOU MAKE IS IN THE WAY YOU ARE DRESSED."

"If you dress like a bum, then they're going to treat you like a bum. If you dress like a hoodlum, they're going to treat you like a hoodlum. If you dress like a businessman, they're going to respect you and treat you like a businessman." From then on, all I wore were suits and jackets. That is me.

—

I can't say that I never read articles or listened to what people said about me, but I have always been confident about who I am.

IF OTHERS HAD A NEGATIVE OPINION ABOUT SOMETHING I SAID OR SOMETHING I DID, THEN THAT WAS THEIR OPINION. IT WASN'T GOING TO AFFECT ME.

If I felt a certain way about my skills, or the way I played the game, then I dealt with those feelings, and I knew what I believed. No one is going to sway me or my beliefs about those very fundamental parts of who I am. That confidence came well in advance of the sixth championship. It started back in high school. I took on a me-against-the-world mentality. I was confident in the knowledge of what I could do on a basketball court.

TO THIS DAY,
I STILL FEEL LIKE I CAN PLAY THE GAME.

The reality is that I can't jump as high or be as agile as I once was. But my knowledge of how to overcome deficiencies remains strong. I know I can't play at the level I once played— I'm not that stupid. But that confidence will never dissipate. It will always be there.

GEORGE KOEHLER *A lot of my friends ask me why Michael isn't still playing. I say, for one thing, he's 42 years old. But Michael can still do what he's always done. I think he's going to be able to do it at 50. For 10 or 15 minutes, he's as good as he's ever been. I've seen it in spurts in pickup games.*

HE MIGHT BE A STEP SLOWER, BUT IF HE WANTED TO GET BACK INTO PLAYING SHAPE, FOR 15 MINUTES A NIGHT HE COULD STILL BE MICHAEL JORDAN. AND WHEN YOU SEE IT HAPPEN FOR THOSE 15 MINUTES, THE HAIR ON THE BACK OF YOUR NECK STILL STANDS UP, BECAUSE IT'S COOL.

HOWARD "H" WHITE *What holds people back? Sometimes it's the fear of succeeding, and they don't even know it. There is a part of us that is so self-conscious that it keeps many people from reaching a destiny that they don't even know is out there.*

That's the part we fight to overcome every day. I remember being at the gym with Michael, and there was this businessman, very successful. He wanted to get back in shape, and he's laying on the board doing some inverted situps. The guy starts talking about how he's getting cramps, and he stops. Michael tells him he has to find a way to get past the pain if he really wants to get back into shape. The guy walks around a little while, comes back, and finally does another set.

Then Michael said, "The mind will play tricks on you. The mind was telling you that you couldn't go any further. The mind was telling you how much it hurt. The mind was telling you these things to keep you from reaching your goal. But you have to see past that, turn it all off if you are going to get where you want to be."

Michael was telling this guy about Michael Jordan. He was describing the things that hold all of us back, those things Michael found a way to get past.

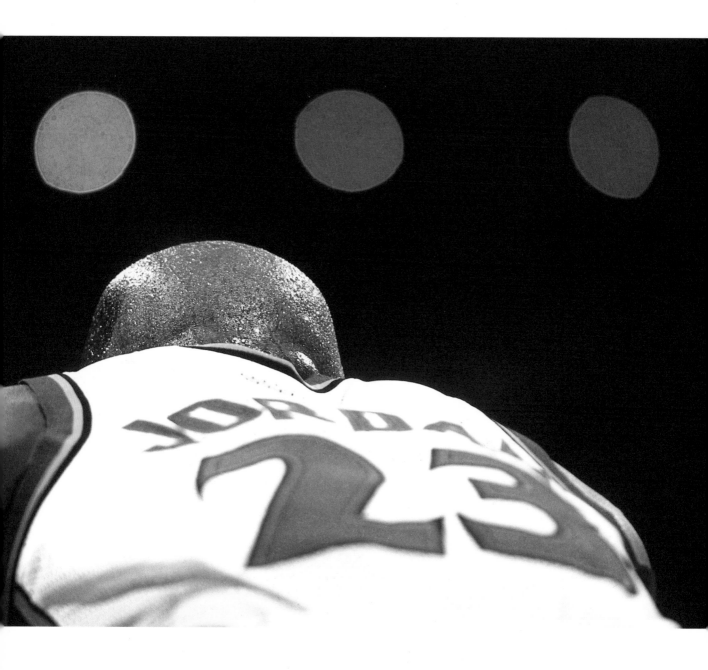

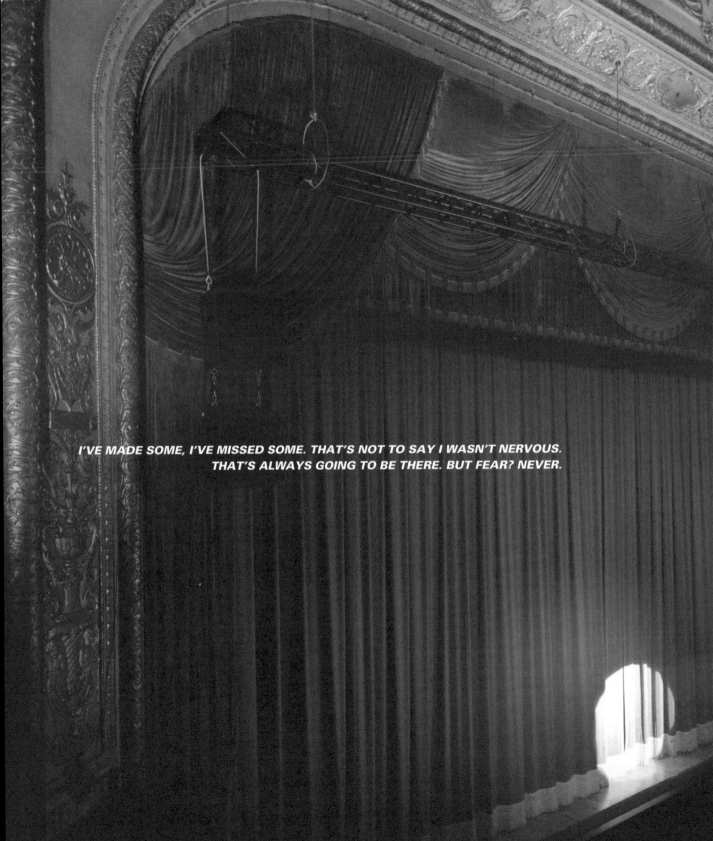

I'VE MADE SOME, I'VE MISSED SOME. THAT'S NOT TO SAY I WASN'T NERVOUS. THAT'S ALWAYS GOING TO BE THERE. BUT FEAR? NEVER.

***THERE WAS NEVER ANY FEAR FOR ME, NO FEAR OF FAILURE.
IF I MISS A SHOT, SO WHAT?***

Maybe even a shot that could have won a game. I can deal with that.
If I don't miss the shot, then I don't miss it—we win. I can rationalize
the fact there are only two outcomes: You either make it, or you miss
it. I could think that way because I knew I had earned the opportunity
to take that shot.

I had put in all the work, not only in that particular game, but in practice
every day. If I missed, then it wasn't meant to be. That simple.
It wasn't because the effort wasn't there. It wasn't because I couldn't
make the shot, because I had taken the same shot many times in
every situation. As soon as the ball went up, there weren't any nerves
because I had trained myself for that situation.

I was as prepared as I could possibly have been for that moment.
I couldn't go back and practice a little harder. I knew I had done the right
things to prepare myself for that situation. One way or another, I knew
I was prepared to be successful. Now, if you know you haven't prepared
correctly, or you know you haven't worked hard enough, that's when
other thoughts and emotions creep into your mind. That's stress.
That's fear.

It's the same process for doing anything, anywhere in life no matter how
big or small the stage. Whether it's running a corporation, taking a test
in second grade or taking a shot to win a game, at that moment you are
the sum total of all the work you have put in, nothing more and nothing
less. If you are confident you have done everything possible to prepare
yourself, then there is nothing to fear.

THERE'S NO STRESS IN LOSING UNDER
THOSE CIRCUMSTANCES.
IT JUST WASN'T MEANT
TO BE.
—

THERE IS NOTHING I HAVE TO DO FOR BRAND JORDAN TO CONTINUE TO GROW
OTHER THAN TO CONTINUE BEING MYSELF.

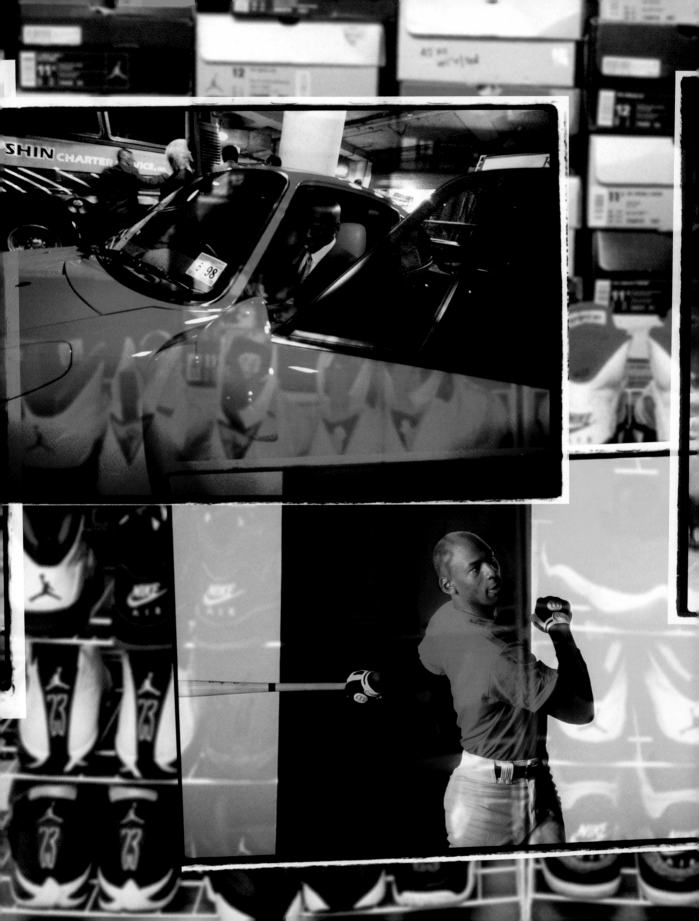

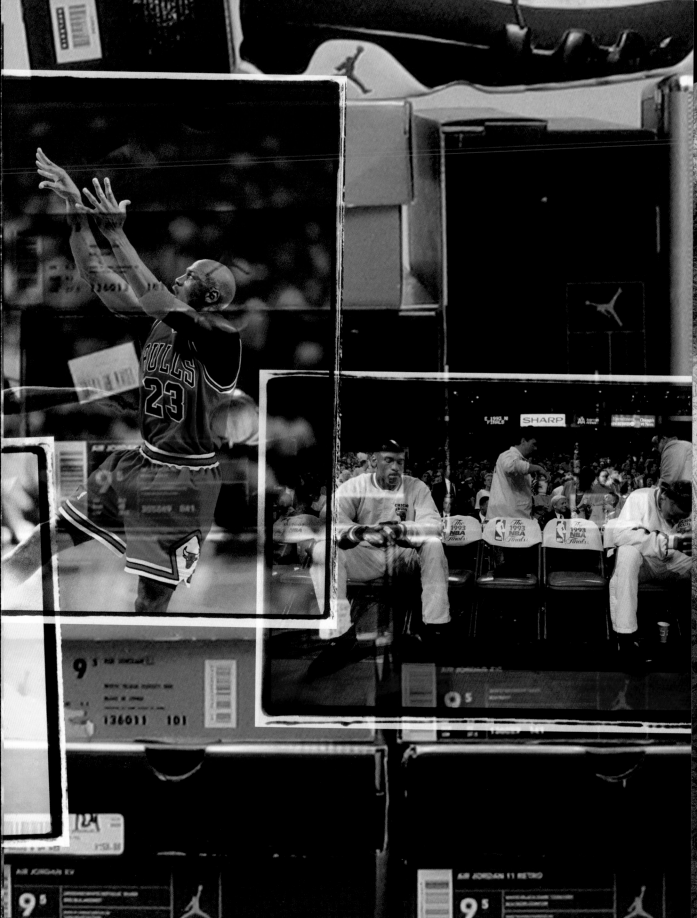

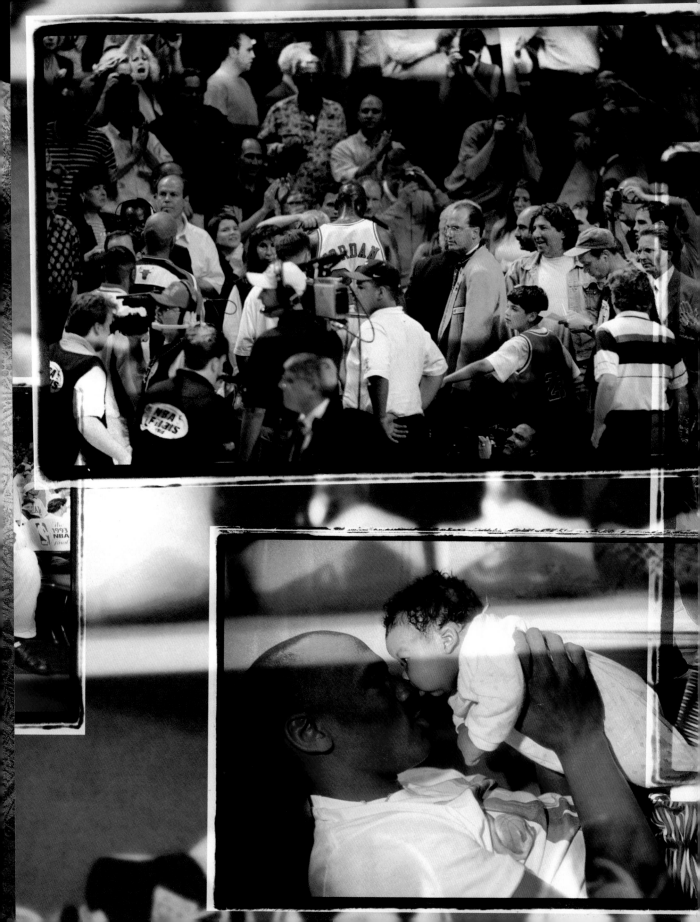

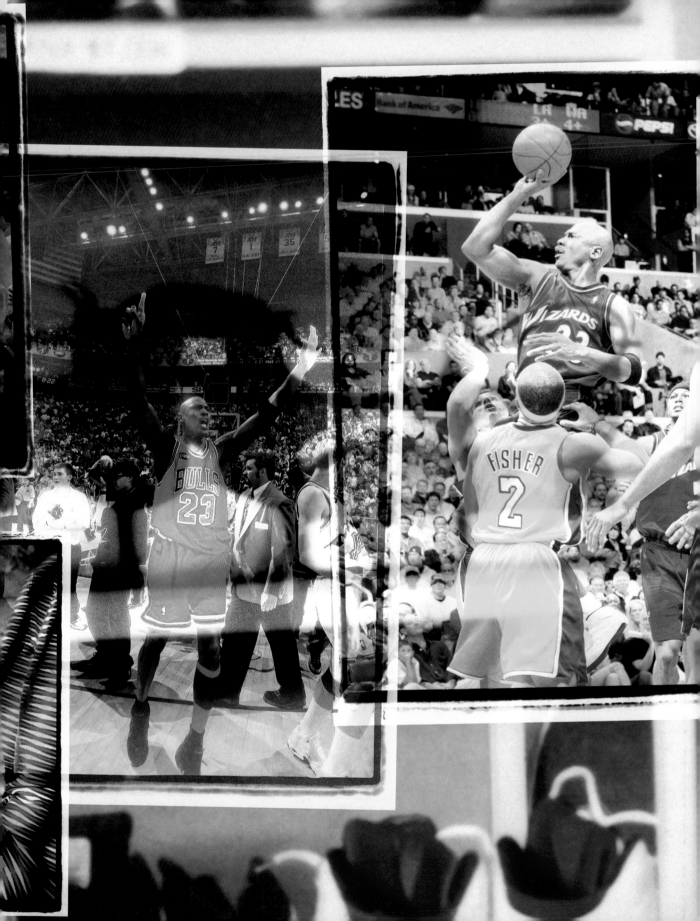

I WANT TO ALLOW WHATEVER IS GOING TO HAPPEN TO HAPPEN AT ITS OWN RHYTHM.

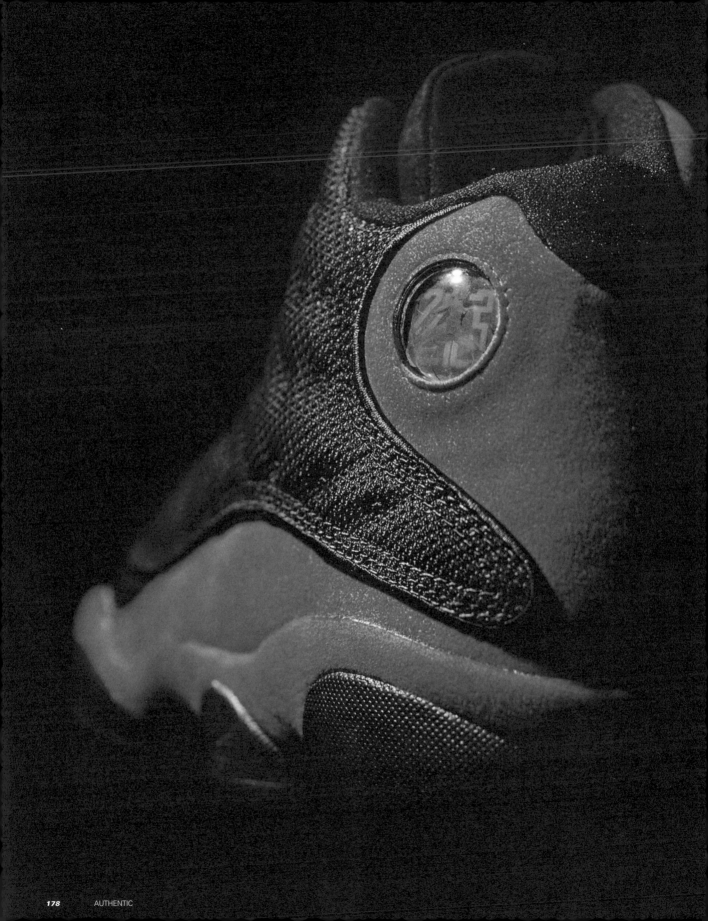

TINKER HATFIELD *I didn't have preliminary discussions with Michael about what he wanted to do with the Jordan XIII. I just had this flash of consciousness about him being a predatory cat. He was so explosive, yet so deceptively passive at times, which was when he'd steal the ball from somebody. He was so smart that he'd trick people into thinking he wasn't quite paying attention. That's how cats are.*

I started talking to Michael about watching him play, and this cat thing popped up in my head. I was talking about this black cat, and that's when he said, "How did you know? How did you know that's my nickname among my close friends?" I didn't know. I just watched him play the game and noticed the similarities.

—

About two years before the XIII came out, my friends started calling me "Black Cat." They felt I was like a panther. I would sneak up on people and attack before they could react. It was one of those things Tinker picked up from my world. I loved it. I thought it was a great example of the way I played the game.

In the big games, I didn't attack the same way every night. I'm a poker player. I like to see the other guy's cards first. Early in the game, most guys are going to give you signs about how they are going to play. The hype is so high that they become overly aggressive. They end up showing their cards early. I liked to sit back and see what direction the game was going. "OK, I kind of thought you'd play that way, now let's see if you can handle the way I'm going to play."

THEY HAD NO IDEA WHAT I WAS GOING TO DO.
NO ONE EVER KNEW HOW I WAS GOING TO COME OUT AT THE BEGINNING OF A GAME.

You knew it was coming; you just didn't know when it was coming or how it was coming. But you could be damn sure it was coming.

—

It was so easy for me to find ways to motivate myself. It didn't matter whether it was the seventh game of a playoff series or the 60th game of another season. I know it's easy to be analytical after the fact and come up with all these wild theories, but my driving force, my passion, was to impress people with what I could do.

That got me through those dog days. It wasn't about scoring titles, or any of those kind of accolades. The most important thing I learned from my father was the passion to prove what I was capable of doing. It was just that simple. It's not brain surgery. If I go to New Jersey for Game 56, we were probably expected to win the game by 30 points in those days. But that never dawned on me.

IT WAS THE IDEA SOMEBODY MIGHT BE SITTING THERE WHO HAD NEVER SEEN MICHAEL JORDAN PLAY.

I thought about that person who had never experienced the excitement or entertainment I could provide. That would be the thought that drove me to play that game. My motivation might come from somewhere else the next night. I had to search out and find reasons to play every game at a high level.

I WOULD WAKE UP IN THE MORNING THINKING, "OK, HOW AM I GOING TO ATTACK TODAY?"

I never knew what my motivation would be until sometime during the day. It wasn't as easy as I went along because I had accomplished so much. I had to trick myself. I almost had to find a test within the test.

Sometimes it was about a coach who was going to create some special defense designed to stop me. Even Phil Jackson, in the later years, started trying to challenge me. He'd say, "MJ, you're not going to be able to do your post-up move tonight because you're playing against a bigger guy." Says who? That's what you say—That's not what I say. So I would use that as motivation, and that became the fuel for that night.

I always looked at it as if Phil was trying to challenge me, not that he was criticizing me. Tex Winter used to criticize me all the time. Tex would tell me, "You're probably the worst passer I have ever seen." I'd say, "Yeah, but I'm probably the best scorer you've ever seen. So why would I pass it?"

I look at these kids today, and they don't know how to trick themselves. They don't even understand the need to find a way to get yourself ready to play at the highest level every night.

People don't realize this, but the Gatorade ads helped the Nike ads. Those Gatorade ads were the ones that families and kids connected to. As much as Nike did, Gatorade brought me into the family. It showed a very genuine side of me, playing with the kids and families. No other commercials did that. In all honesty, "Be Like Mike" was similar to the Mean Joe Greene spot. How many times did you have to see that commercial with Joe Greene to get the connection between a big monster of a guy and that little kid? He was an iconic guy who played aggressively with a killer instinct. Same exact thing.

UP UNTIL THAT POINT, I WAS CONNECTING WITH THE BASKETBALL ENTHUSIAST, THE GUYS AND GIRLS WHO KNEW THE GAME.

Gatorade connected me to the kids. Kids could relate. It was like a cartoon. That's why there are a whole lot of kids who might not have seen me play at all, but they remember that commercial.

SO WE CAN CONNECT.

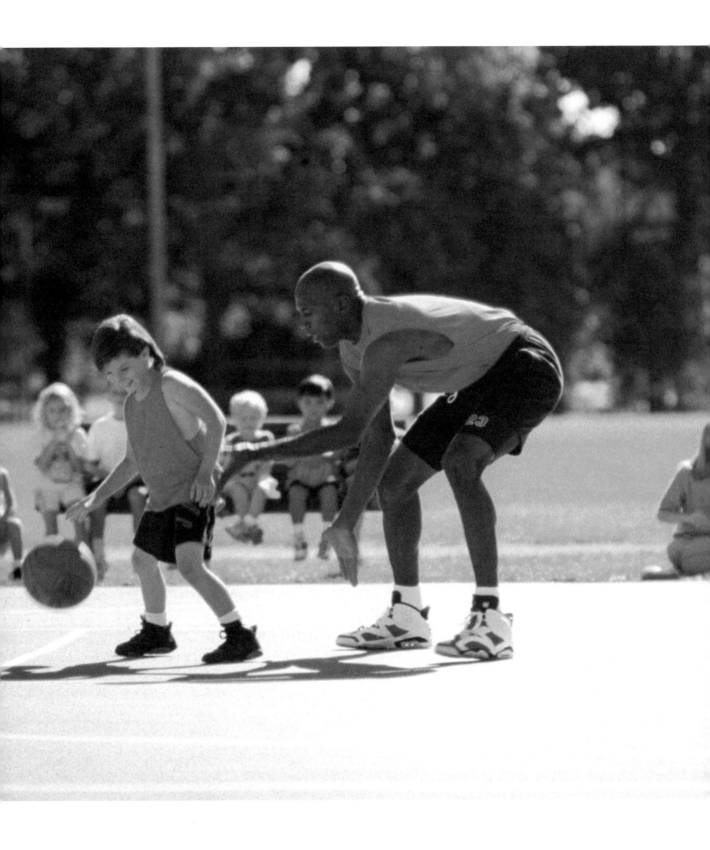

TINKER HATFIELD *The back stories just kept getting more rich and interesting. The XIV was revisiting Michael's passion for cars, in this case a Ferrari he had at the time. The idea for the XV was the X-15, which was the fastest plane ever flown. The X-15 set all kinds of speed records in the 1960s. It was a rocket plane that was a forerunner to the U.S. space program.*

It became the inspiration for the aggressive, sharp-edged, unusual shape of the shoe. The idea was to pay respect to Michael because he was like the X-15, the best there ever was. That shoe became all about the design of that plane.

MICHAEL WASN'T PLAYING, BUT HIS GAME, THE MEMORY OF HOW HE PLAYED, WAS STILL FRESH.

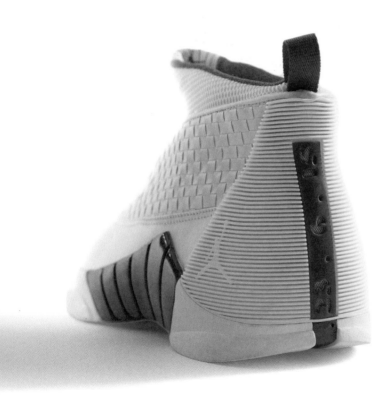

Everything was in its place. I came from a small town. No one knew who I was. Everybody was getting well-publicized, but I had to lie to get that status. Once I did, there were people who thought I was too good to be true, so they challenged me, which was right in line with how I went about everything. I didn't get tarnished by national attention or success at a young age. I didn't experience the spoils. I always felt like I had to prove myself, one way or another.

WHEN I DID GET ATTENTION, I WANTED TO SHOW PEOPLE THAT I DESERVED IT.

I never felt like it was enough to be noticed. That approach carried me through my entire career. That was my strength.

I NEVER LOST THE DESIRE TO WORK HARD, SET GOALS AND ACHIEVE. THAT NEVER WENT AWAY FOR ME.

At Washington, Kwame Brown said I was hard on him, and I was because I never believed he had ever tried to push himself. He had developed bad habits, and I don't believe in bad habits.

OUR CULTURE NEEDS TO SEE EXAMPLES.

You can hear about how somebody played, or read about the best way to achieve success, but people need to see examples.

UNTIL THEY SEE, THEY WON'T DO.

It's easy to talk about what Jerry West did, but it's not as easy to see what he did.

Tomorrow's kids are going to have to see someone playing hurt, see someone practicing the day after winning a championship. We have to provide examples so they can relate to that ideal. Otherwise, they will get bad habits. If we lose that gap, then it starts to fade away, and 20 years from now you will never see someone play sick, or get out on the floor with a sore ankle.

GEORGE KOEHLER *He really loves the game. If you sit with Michael and watch a basketball game, you would think he was going to break the television. He screams, he yells. It's amazing how astute he is. He knows the strengths and weaknesses of every player on the floor. It was part of his preparation as a player. It went into that computer in his head and stayed there.*

It was the same in Washington. He didn't come back to play. He came back to evaluate the talent. He wanted to go back to the front office and be more efficient.

HE WANTED TO LOOK THESE GUYS IN THE EYE, PUSH THEM TO SEE IF THEY WOULD PUSH BACK.

He wanted to see a player's work ethic. He wanted to know if they showed up on time. It was all to learn about the league. It had nothing to do with his ego. He didn't miss the limelight.

I saw guys sitting on the training table for two weeks with a sprained ankle. Michael had a back spasm one day, and we literally had to carry him off the floor and drive him home in a truck because he couldn't move. They gave him heat treatments and cold treatments all night long, and he played the next night.

He had fluid drained off his knee, I don't know how many times.

ONE NIGHT HE HAD 22 CC OF FLUID DRAINED. DO YOU KNOW HOW MUCH THAT IS? AND THAT'S BEFORE THE GAME.

He came dressed to do business every night. He wasn't wearing jumpsuits and Timberland shoes, looking like a thug. Michael showed up wearing a $3,500 suit because he was going to work. There's no changing him.

CURTIS POLK *What did he have to gain? Others made it seem like coming back was all about competitiveness, or that Michael missed the spotlight, or that he had the itch and it had to be scratched again. I think it would be unrealistic to say there wasn't some small percentage of all that in his decision. But his children really hadn't seen him play at a time when they could understand who he was and appreciate what he had been able to do.*

Michael really valued the job with the Wizards, and he thought playing was the best way to evaluate the talent. The only way Michael felt he could really translate the work ethic that was his legend was to have them live it every day rather than just hear about it. The practices were amazing. But that first year before he finally had the knee surgery, the tendinitis was really bad.

TINKER HATFIELD

*I ACTUALLY DESIGNED THE XVI,
BUT IT WAS MY INTENTION TO BRING ALONG
ANOTHER DESIGNER AND HAND IT OFF.*
*WILSON SMITH TOOK THE ORIGINAL SKETCHES, WHERE WE WERE STUDYING
THE SPAT IDEA. WE WERE BEING QUITE CONTRARY TO THE XV BY CREATING
A SPATTED MARCHING-BAND KIND OF SHOE.*

I was looking for a way to shift back, kind of what Michael had done. I didn't really think much about the pressure while we were doing all these shoes, until after Michael retired the second time. People were yet again questioning whether we should be doing any Air Jordan shoes. There were all kinds of people who felt, once more, that we were done with Jordan shoes. To Mark Parker and [Nike co-president] Charlie Denson's credit, they said we should keep moving forward.

We were doing that year after year after year. Without realizing it, the process was taking a toll on me. This shoe was not only expected to be a big moneymaker for Nike, but the entire shoe business relied on the next Jordan shoe to drive people back into the stores.

The XVII was inspired by jazz. The shoes became the most expensive ever in the line. There were all kinds of questions to answer. What do you do when you switch design régimes, and Michael is more distanced from the game? Well, they brought in Mike Phillips, the musician. He wrote music for MJ, and there were events built around his music. The shoe had jazz notes molded into them. The story was about improvisation, which is what jazz is all about.

IT WAS LIKE, WELL, IT'S NOT THE SAME ANYMORE, SO YOU HAVE TO IMPROVISE A LITTLE BIT.

You could probably say those three shoes [XVII, XVIII, XIX] maybe didn't move the needle on the dial like some before, but you also can safely say they did well. I think in their own way, those shoes were successful by virtue of keeping the lineage alive and pushing design.

It didn't dawn on us that the XX would be the opportunity to blow it back out of the water again. You have to give Gentry Humphrey credit for being the first one to recognize the unique opportunity to get MJ and myself back involved.

IT ONLY TOOK ME ABOUT FIVE SECONDS TO SAY YES, AND I GOT MY GROOVE BACK.

I forced the issue with Michael, and he gave me his time and energy. I think we met more on the XX than any other shoe. In a way, he was forced into this reflective mode by the notion that it was time to tell some of these stories that would remind people of the legend, but at the same time turn some young people on, as well.

The shoes we created over the years were not contrived from a temporary fad or flavor-of-the-month thing. There is a pure foundation. I am most critical of the design work when I see someone throwing elements onto shoes just to make them look cool.

THERE HAS TO BE A SOUL TO THE PROCESS.
THERE HAS TO BE A REAL STORY.

MICHAEL IS SUCH AN ICON AND SUCH A LOFTY IDEAL THAT I'M SURE IT'S A LITTLE

INTIMIDATING TO WORK ON HIS PRODUCTS. IT'S A TOUGH GIG. **THAT'S LIFE.**

BEYOND

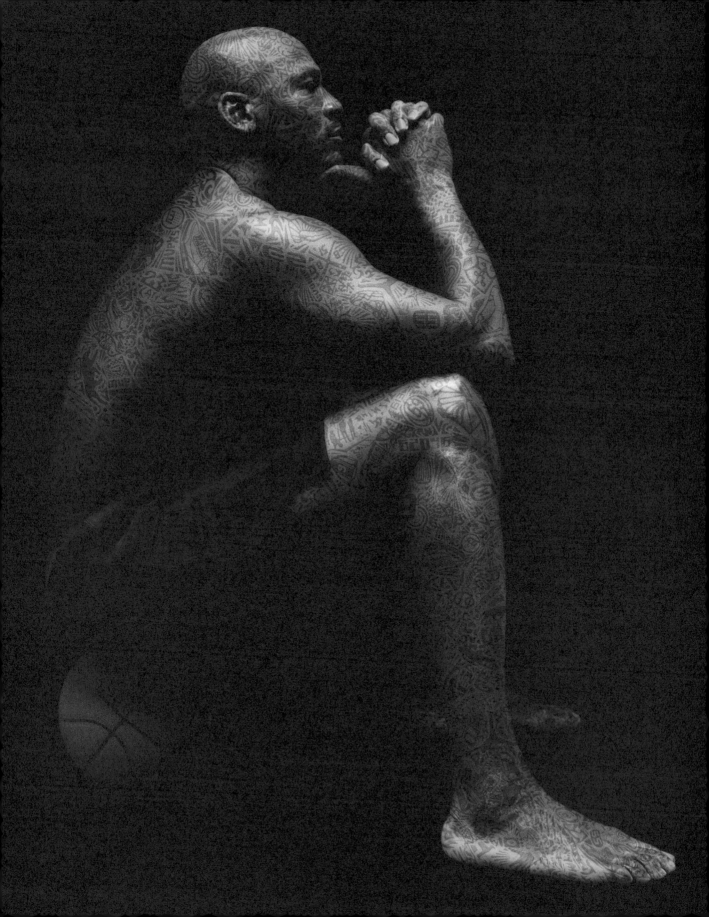

If we come up with a creative direction at Brand Jordan that we feel showcases our personality and matches up with how we want to be represented in the market, then that's the direction we take.

IT'S PURE. IT'S HONEST.

It's not a gimmick. Nothing about the Jordan brand has ever been a gimmick. We have earned the respect of our consumers because they know we aren't following the latest fad to grab a quick buck. When you see a Jordan product, it's genuine. From the quality of the product to the messaging in the commercials, nothing is contrived.

IT'S REAL.

When I talked about how many times I failed on the basketball court, people could relate to that. We weren't trying to portray Michael Jordan as being infallible or perfect. I did fail. We were being honest about who I was, not only as a basketball player, but as a human being.

For the XX, we asked, "Who is going to be next? Who is going to come along and take Michael Jordan's spot."

In one way or another, just about everyone is going through that kind of search. The idea that it could be you is something all of us can relate to when we think about our goals. It doesn't have to be someone else getting all the accolades. It could be you.

THE PRODUCTS, COMPANIES AND PEOPLE WHO STAY TRUE TO WHO THEY ARE USUALLY END UP BEING AROUND FOR A LONG TIME.

The ones that lose their way by jumping on one fad or another, or trying to be something other than what or who they are, don't last long. If you are trying to make your way through a maze, and your decisions come from

the inside, from your gut, nine times out of ten you won't find yourself running into a wall. But if you rush into something, make decisions to appease somebody else, or chase the easy dollar, then you are going to find that wall.

We follow what we feel at Brand Jordan. It's an innate ability to calculate from the inside out. Products and people that have been calculated and packaged can be replicated because there's no mystery. It's packaging, style over substance. But the products and people that last, they started from somewhere else.

You can't use gimmicks and hope to duplicate something real. I can't walk around a commercial set wearing a hooded sweatshirt and combat boots. That's not who I am.

At one point in time that image might have resonated with a core consumer, but after that's over, where do you go? You can't go backwards. All of our competitors are trying to work up to Brand Jordan because we have sustained a level of style and creativity for 20 years.

AS LONG AS WE STAY TRUE, STAY HONEST, STAY STYLISH, STAY INNOVATIVE, STAY FOCUSED ON QUALITY OVER QUANTITY, THEN NO ONE WILL CATCH US BECAUSE WE'RE ALWAYS GOING TO BE LEADING.

FADS ARE FADS; THEY COME AND GO.
THAT'S NOT WHAT BRAND JORDAN IS ABOUT. AND THAT'S NOT WHO I AM.

Why did I get into motorcycle racing? Because no one else can, or will. The Jordan brand has been established based on the idea that we can do things that no one else can or would do. We have been successful for 20 years because we have remained committed to creating our own style.

It's the difference between making those highly calculated decisions versus listening to your gut. Now there's certainly a place for research and analysis, but who says all those numbers add up to the right answer? You have to know. Apparel is fashion. It's a six-month cycle. Looks change about every six months. If you are not prepared to change that quick, then you are going to be left behind.

WE ARE RIGHT THERE WITH THE FASHION LEADERS.
IN MOST CASES, WE'RE AHEAD OF THEM. WE CAN CHANGE. WE CAN PUT OUT SOME WILD STUFF.

We might not make $10 million, but we can make $1 million or $2 million and still attract consumers who want to see what's next.

TO ME, JORDAN IS RAP, CONTEMPORARY YET CLASSIC. BUT IT'S STILL RAP.

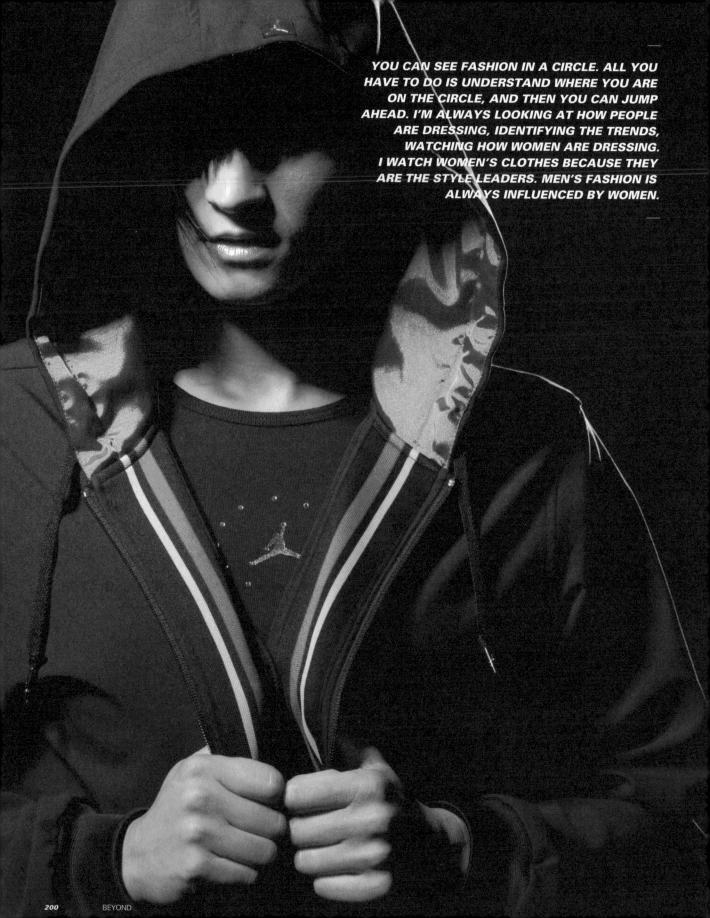

YOU CAN SEE FASHION IN A CIRCLE. ALL YOU HAVE TO DO IS UNDERSTAND WHERE YOU ARE ON THE CIRCLE, AND THEN YOU CAN JUMP AHEAD. I'M ALWAYS LOOKING AT HOW PEOPLE ARE DRESSING, IDENTIFYING THE TRENDS, WATCHING HOW WOMEN ARE DRESSING. I WATCH WOMEN'S CLOTHES BECAUSE THEY ARE THE STYLE LEADERS. MEN'S FASHION IS ALWAYS INFLUENCED BY WOMEN.

TINKER HATFIELD Nike has tried to replicate what we have done with Brand Jordan, just like a lot of other people. But there's never been a situation like this one with Michael. When somebody signs a shoe contract, they expect to be the next Michael Jordan. They all say that. They all expect it to happen.

But it hasn't happened since Michael. When magic happens, it's often an unusual confluence of events. There is something about the combination that makes the magic. Being a former athlete, for example, and being a designer is not common. That alone is unique. Michael is a very unique person for all the reasons we now know. Phil Knight was very progressive. Nike was an aggressive, swashbuckling kind of place. Crazy things happened all the time at Nike in those days. Not just Michael Jordan, but other things that only could have happened there.

I think all of that just came to a nice little intersection.

You read about athletes or performers who knew when they were 7 years old they wanted to win an Oscar or compete in the Olympics. They put everything into those dreams, and with a little bit of luck it sometimes happened.

That definitely was not the case here. We were flying by the seat of our pants, hoping to do the best job we could. No one, including Michael and Phil Knight, ever thought it would become anything like it has become.

NOTHING LIKE THIS HAD EVER HAPPENED BEFORE, AND IT MAY NEVER HAPPEN AGAIN. WE WERE DEFINITELY HOPING TO MAKE BETTER PRODUCTS, MAKE GOOD DECISIONS, DEVELOP A GOOD BUSINESS, BUT THE RESULT HAS BEEN PRETTY DARNED AMAZING.

HOWARD "H" WHITE Forget about Michael for a moment. It's hard for most people to dig deep enough within themselves to understand his core.

IF ALL YOU UNDERSTAND ABOUT YOURSELF IS WHERE YOU STOP, THEN YOU CAN'T APPRECIATE WHERE HE'S GONE.

Here's a guy who has created millions and millions of dollars that have trickled down to all kinds of people and businesses. But that has never been the point for Michael. It was about a deep, yet fundamental process of getting something done.

Look at all these pieces that combined to create something phenomenal. Tinker: White boy, from way out there somewhere in Oregon. I'm a guy that comes in from the East Coast. MJ's a Southern boy from North Carolina. Phil is a Stanford MBA. These eclectic parts created something far bigger than they were individually.

I bring my creativity to the table, combine it with what Mark Smith is able to do, then Tinker comes in, and we peak. The next thing you know, something beautiful has evolved, even though we've come from completely different angles.

If any one of us had such a strong sense of being right, or a desire to win the discussion and impose our will on the group, then it wouldn't produce the same product. We realize everybody in the circle is creative, and that your twist with my turn with his nuance is beautiful to see.

WE BRING OUR PERSONALITIES, OUR VISIONS AND OUR CREATIVITY TO THE DISCUSSION, AND WE DON'T GIVE A DAMN ABOUT GETTING CREDIT.

We are there to create something beautiful, something representative of what the brand is all about. What I think they like about me is that I can admit when I'm wrong, and I can accept criticism. And I can accept creative insight coming from someone other than myself.

There are a lot of people who can't do that, or won't allow themselves to. They feel like it's an attack on their intelligence, or a negative comment on their ideas. They want so much credit that they can't share the credit. But that dynamic is just as destructive inside a creative team or a corporate setting as it is on the basketball court.

IN ITS HIGHEST FORM, BUSINESS IS A TEAM GAME.

The teams that can accept that philosophy are the teams that have the best chance—long term—to be successful. Team sports are no different. Give me five guys who want to work hard and play together, and I'll take those guys every time over more talented players who can't come together for the good of the group.

For years people viewed me as an individual, and not a team player, because I scored so much. But I was a team player. I was just filling my role at that time. I had to score for us to have a chance to win. Brand Jordan is no different. Even though my name is on the product, it's a collaborative effort.

I HAVE THE SAME KIND OF COMMITMENT TO THE BRAND THAT I HAD TO BASKETBALL. I HAVE AN INTENSE FOCUS AND DESIRE TO MAKE THE BRAND SUCCESSFUL.

BUT I'M NOT SO DOMINANT THAT I CAN'T LISTEN TO CREATIVE IDEAS COMING FROM OTHER PEOPLE. SUCCESSFUL PEOPLE LISTEN. GUYS WHO DON'T LISTEN, DON'T SURVIVE LONG.

The Warren Buffetts and Bill Gates have had to open their minds at some point in time to other opinions, if for no other reason than to hear competing thoughts. You have a lot of people whose minds are closed. They won't hear suggestions from others. I can't get along with those people.

———

CURTIS POLK *There is no master plan. Michael doesn't work like that. If someone would have told me five or six years ago that he would be involved in motorcycle racing, I would have laughed. I'm sure the same would be true about something that might happen five or six years from now. Michael is into challenges and finding things that present a genuine passion for him.*

He has a passion for cars, watches, the clothing he wears, the look of the apparel and the shoes the brand creates. It's a question of Michael finding things he can embrace. Business opportunities come along that have big moneymaking potential, but if Michael doesn't have a passion for the ideas, then they aren't going anywhere. The motorcycle team has not been profitable, but that fact has nothing to do with his level of interest.

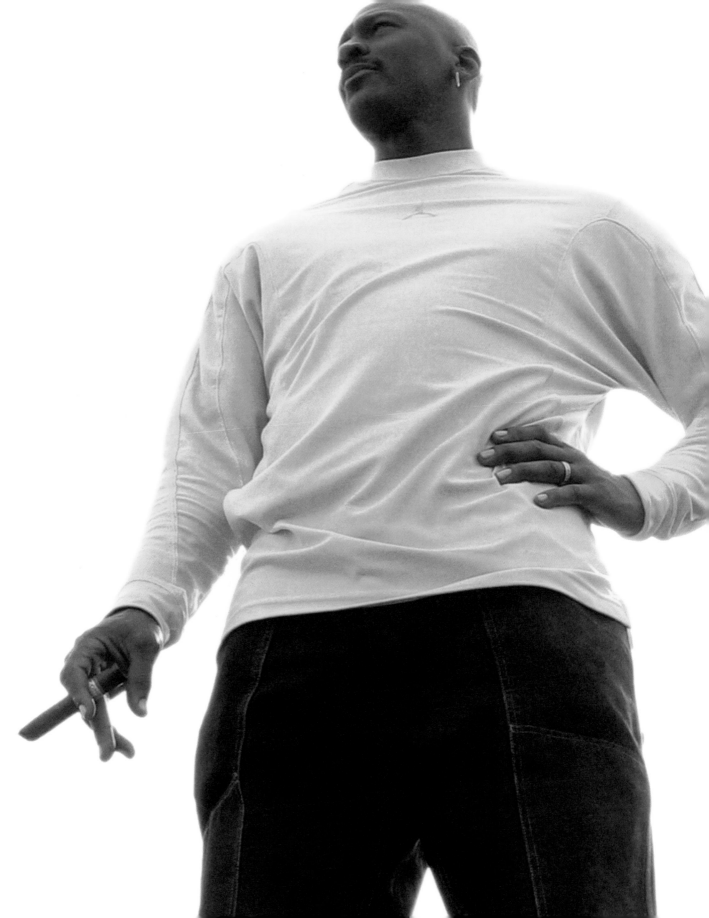

PRICE 25 CENTS

ZOLA'S

FORTUNE

TELLER

CC 34

IN ALL HONESTY,
I DON'T KNOW WHAT'S AHEAD.

If you ask me what I'm going to do in five years, I can't tell you. This moment? Now that's a different story. I know what I'm doing moment to moment, but I have no idea what's ahead.

I'm so connected to this moment that I don't make assumptions about what might come next, because I don't want to lose touch with the present. Once you make assumptions about something that might happen, or might not happen, then you open up the possibility of making mistakes. You start limiting the potential outcomes. I don't make assumptions. I know what I know, and I deal with my life based on what's happening right now.

FIVE YEARS FROM NOW? I KNOW GEORGE AND I WILL BE SOMEWHERE HAVING A GOOD TIME.

Afterword / by Mark Vancil

For more than 21 years, I have watched Michael Jordan, often from a privileged vantage, grow up and into a global icon. To be sure, he is different from the rest of us, though not in the ways of conventional wisdom.

More than ever the results, particularly those measurable, seem to have very little to do with God given physical talent, or even the possibility that the planets have indeed lined up for him. Look around, and there are all kinds of players with incredible physical attributes, some of them barely 18 years old. And it's just as likely the planets have lined up for others the way they have for Michael. We just don't know who they are because on the inside they aren't close to being like Mike.

What seems more apparent now than it ever did while he was playing is that the most remarkable aspects to Michael Jordan are those that can neither be seen nor measured. As with passion, all we have is circumstantial evidence suggesting the presence of something powerful. Trying to apply any traditional analysis to define Michael's enduring connection to people in virtually every corner of the globe likely only distances one from the answer. At the same time, Michael's exterior, the part of him we all see, appears to be nothing less than the manifestation of a core that has always defied the larger culture around him.

Michael approaches life, in all its forms, in a way completely at odds with a culture that otherwise seems to have been contorted by an insatiable appetite for immediate gratification. In short, it's the process that drives the results and it's the process that makes Michael Jordan like no one else. For all the wonder it has produced, the method sounds remarkably simple as described by Michael. Old school, as they say: "Step by step… No shortcuts… Hard work determines the dividends… Uncompromised… Authentic… Nothing of value comes without being earned… Small things add up to big things."

But layer over intense passion, integrity, commitment, focus and constant scrutiny to even the smallest details, all of which when combined essentially eliminate fear, and the mix becomes the multiplier that turns physical talent into Michael Jordan results. He is fearless because he is never anywhere but the present moment. He doesn't look back and wonder what might have been because he doesn't look ahead and worry about what might not be. He is right here, right now, all the time. People spend 20 years sitting in an ashram in Tibet trying to manifest that sense of themselves and their place in time. Michael Jordan does it naturally and with magnetic grace all his own. Of all his gifts, it's possible none is more defining.

But it doesn't stop there. Look around Michael and another thing you notice is the quality of people who have been inside his circle for more than 20 years, people like Dean Smith, George Koehler, Fred Whitfield, Howard White, Tinker Hatfield, and Rod Higgins. They are polite. They are respectful. They are accomplished. And they mirror the fundamental values that flowed from James and Delores Jordan down through Michael and into everything he has created.

My sense is that his enduring appeal can be traced to our search for authenticity, the tangible expression of all those intangibles that seem to accompany true greatness. Then again, maybe what we have always seen in Michael Jordan is nothing more or less than a higher vision of ourselves, something beyond what we might otherwise allow ourselves to imagine.

Too idealistic? That's fine. But the standard isn't perfection. Everyone fails that test. As "H" White wisely noted, if all we understand about ourselves is where we stop, then we can't begin to appreciate where Michael Jordan has gone.

And the beauty of his example is that it's accessible to all of us.

———

Rarely has a journey been so completely inspiring as the one I have been on for much of the past year. I have met people who have enriched my life, while experiencing up close the commitment that explains, if not defines the success of Nike and Brand Jordan. Across the board, the same is true of VSA Partners, who marched through a relatively daunting process and weeks of late nights with the kind of class and compassion that defines the company.

Estee Portnoy provided support, guidance and kindness from the first phone call while Curtis Polk made sure we never veered too far from center, and David Falk provided much needed insight. Their presence was as important as their expertise.

And then there is Tinker. If he had contributed only his time, I would have been grateful given his accomplishments and insight. Instead, Tinker offered himself, something that comes naturally to him. Rarely do people articulate their passion with such grace and dignity. But that's Tinker Hatfield. Long before the book process began, I was told of his iconic status in the sneaker world. Now that we have finished, I realize that limiting Tinker's impact to any one space is far too restrictive for a talent whose work has influenced so many so far beyond athletic product design. The fact that he also happens to be a wonderful human being explains a lot about the bond he and Michael share.

As with any project, particularly one with tight deadlines, individuals came forward day to day, each contributing a piece to what became the whole of this book:

At Nike Mark Parker not only fit us into his schedule, but contributed as only he can. Without Mark's genuine appreciation for the creative process, none of the original art in this book ever would have been created. The unique pieces produced by Liberatore, Mister Cartoon, Mode 2, Pushead and Terrada started with Mark. He not only helped us understand what we were looking for, but he made it happen as well. I suspect Mark has done that a lot at Nike over the years.

Mark Smith's name came up countless times in conversations with Michael and when I came to understand the breadth of his genius, it all made sense. Great talent; better guy.

The third Mark who made the trip all the more pleasurable was Mark Thomashow. He, too, lived up to and beyond the advance billing.

At Brand Jordan Larry Miller's innate goodness speaks to the values that have contributed to the company's success. Warm, generous and without pretense, Larry never hesitated whenever we needed an assist. Keith Crawford's creative talent is mirrored by his compassion and commitment. He found time in his schedule at a moment's notice, and when crunch time came, Keith delivered. The same is true of Roman Vega, who makes it all look incredibly easy. He too turned with little advance warning to be sure we had everything we needed no matter the request. Andy Whiteside made things happen with the same kind of apparent ease that defines the experience with everyone else at Brand Jordan. Gentry Humphrey contributed his expertise, Pete Montagne looked high and low for images, Eileen Belle and Ilona Wiley helped us navigate.

At VSA Partners If it's true that we can tell where we at any given moment by the quality of the people around us, then I'm not sure I've ever been in better place. Curt Schreiber's considerable talents combined with an uncommon graciousness and integrity make him the leader that he is and the friend we all should have. With Curt out front and Ashley Lippard driving it all from the inside out, they made the design process appear effortless despite nights that often didn't end until well into the next day. Like everyone else associated with this project, Ashley brought her own unique passion and she never wavered. The fact she grew up covering the walls of her bedroom with Michael Jordan press clippings, and honed her emerging creative talents by designing her own versions of Air Jordan shoes, only added to the mix. The same could be said of Amy Laney, Richard Renno and Amy Glaiberman, who contributed their time and talents to the many details.

Of Special Note This book would not have been possible without the wonder that is Les Baden. He never once failed to answer a call for help, provide direction or ferret out a solution. All this while running Les Badden Creative Office, providing a bright light to the Portland arts community and doting on his beautiful family. It became very clear very early why Les has personal relationships that stretch across virtually every creative medium around the globe. He is an uncommon man of depth, compassion and skill.

Once more, Ken Leiker answered the bell at a moment's notice and provided his unique skills to the finished product. He remains a gift in person and talent to all of us who continue to have the pleasure of his company.

And thanks to John Ziccardi this book found its way into the Simon & Schuster family. Everyone should have a friend like John, and I'm glad to say I do.

At Simon & Schuster/Atria Books Jack Romanos listened when no one else would, and understood the upside, as he has no doubt done countless times before, when others could not. At Atria Books, Judith Curr's creativity is matched by her kindness; she proved to be the perfect publisher for whom to work. Peter Borland calmly juggled multiple books while making us feel as though ours was the only one on his list. And Justin Loeber proved a tireless professional.

At Home The freedom to create often demands the freedom to deviate from normal schedules. Through it all, my wife, Laura, held our life together by caring as only she can for our beautiful children, Alexandra, Samantha, Isabella and their little brother, Jonah. I remain in awe of each one of them and humbled by the blessing of their presence in my life.

Special thanks Walter Iooss, Jr., Steve Ryan, Todd Piper-Hauswirth, Robyn Paprocki, Drew Brooks, Bill Smith at Bill Smith Photography, Bob Rosenberg, John Vieceli, Frank Fochetta, Melinda Weinstein, Kim Kief-Carroll, Dan Long, Tina Warner, Fraser Cooke, Nikki Neuburger, Rob Mertz, Michelle Sorge-Johnson, Joe Amati, Tom Foxen, Michelle Barber, Jackie Thomas, Chris Calhoun and Tom Fox.

ATRIA BOOKS

1230 Avenue of the Americas
New York, NY 10020

ISBN-13: 978-0-7432-8400-4
ISBN-10: 0-7432-8400-3

First Atria Books hardcover edition October 2005

10 9 8 7 6 5 4 3 2 1

ATRIA BOOKS is a trademark of Simon & Schuster, Inc.

For information regarding special discounts for bulk purchases, please contact
Simon & Schuster Special Sales at 1-800-456-6798 or business@simonandschuster.com

Manufactured in the United Kingdom

Credits

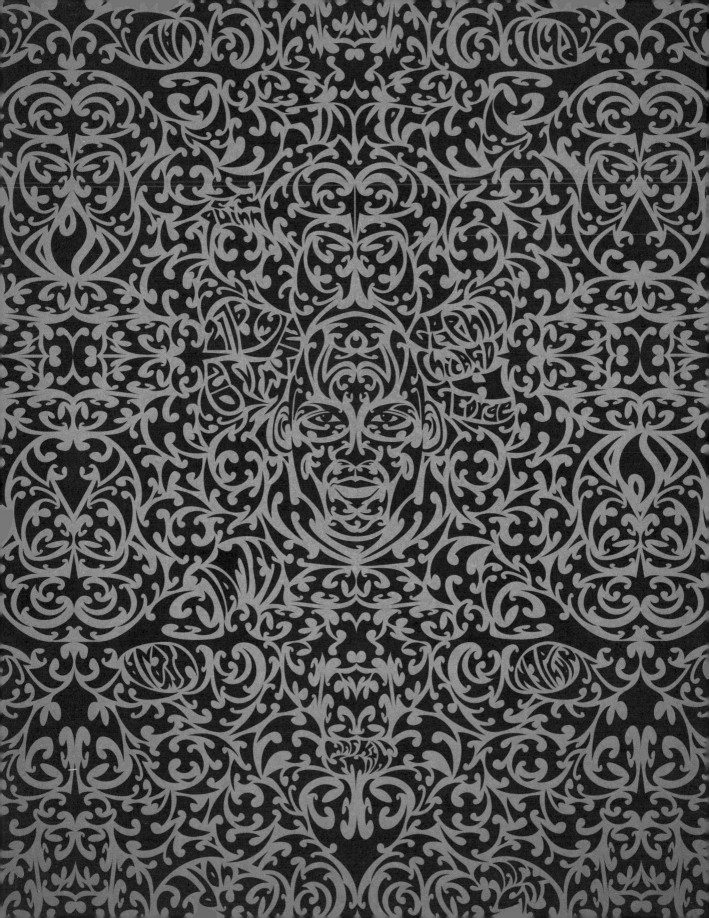